PHOTO
CRAFT

Other books by Leslie Linsley

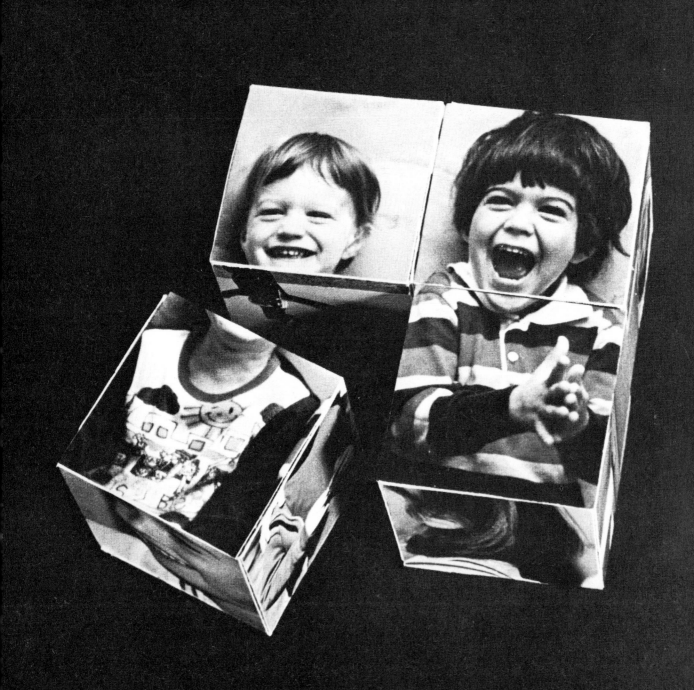

PHOTO CRAFT

by Leslie Linsley & Jon Aron

Delacorte Press/New York

Published by
Delacorte Press
1 Dag Hammarskjold Plaza
New York, N.Y. 10017

Manufactured in the United
States of America

First printing

Designed by Jon Aron

Library of Congress
Cataloging in Publication Data

Linsley, Leslie.
Photocraft.

1. Photographs—Trimming, mounting, etc.
2. Handicraft.
I. Aron, Jon, joint author.
II. Title. TR340.L46 770'.284 79-25010

ISBN 0-440-06802-9

ISBN 0-440-56812-9 (pbk.)

Contents

PHOTO CRAFT

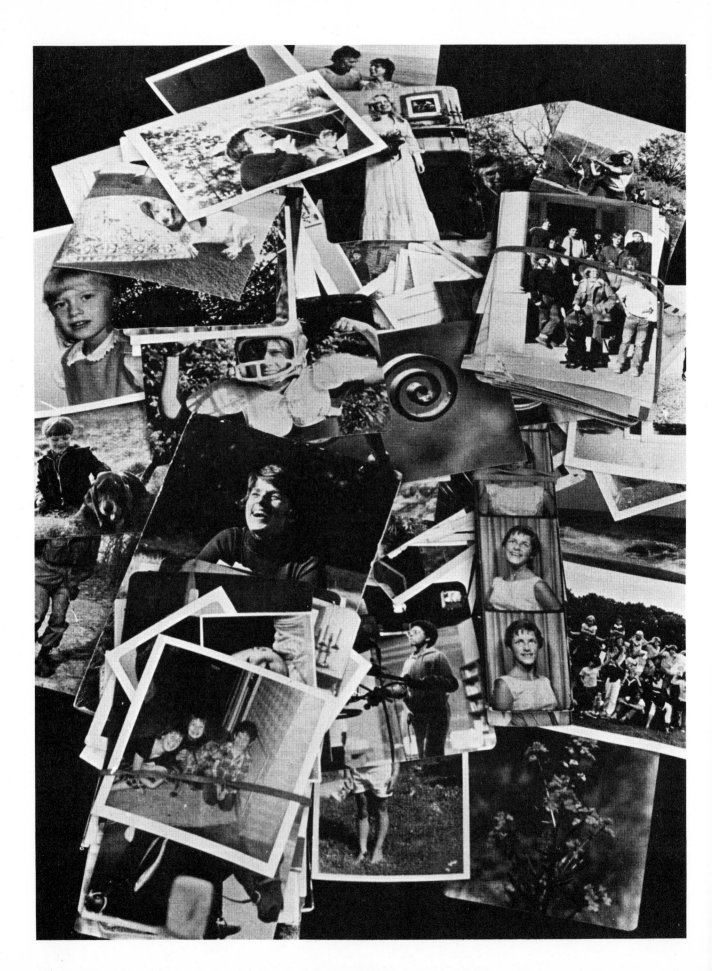

Introduction

Almost everyone takes pictures and many households have more than one camera. And all of us have more photographs than we know what to do with. We frame them, put them in albums, and send them to friends. The rest, even those that are fuzzy and out of focus, stay around the house forever and get passed from one generation to another. After all, we really can't throw away Aunt Susan's picture just because we can hardly see her in the background. The picture of Grandpa may have a thumb coming in from one side, but it is the only one we have of him. And although the photographs of Mom before she went to Weight Watchers may make her upset, we loved her then just as much as we do now.

Interest in amateur photography has exploded in the past several years. Pictures are easy to take, laboratory processing techniques have improved, prints are cheaper and of higher quality than ever before. For the person who is interested in more advanced photography, cameras and accessories are extraordinarily varied and are available in a wide range of prices.

Although there is a multitude of albums, and techniques for putting pictures in these albums, and there are all kinds of matting and framing devices, still, practically everyone has hundreds of photographs that she or he doesn't know what to do with.

Photocraft was written to solve this problem. It is not a book about how to take photographs but one to show you what to do with all those photographs you've already taken. The craft ideas presented here all use snapshots as the basic design element.

The photographs that we have used are for the most part amateur prints. We wrote letters to friends and family asking them to send us some of the wonderful and not-so-wonderful pictures they had taken over the years. And they sent a wide assortment ranging from Jon's mother's grammar school graduation picture of sixty years ago to a shot of the newly born, youngest member of the family. I dug into a box of hundreds of photos taken by a lot of very bad photographers in my family and we found we were able to use even the worst of them so long as there was some redeeming quality. Even

What would you do with these pictures? See page 144.

the traditional bare-bottomed baby shots that were dark and out of
focus, when cropped correctly yielded some interesting possibili-
ties. At times working on these projects took a sense of humor—for
instance when Jon insisted on using a picture of me at age four or
five, what I consider to be my rough-and-tough stage. It's not easy
to keep face when you show up this way in your own book.

On a trip to Boston we spent an hour taking pictures of ourselves
in one of those quarter machines in a drug store. All they lack is a
prison identification number under each face but they are usable.

There's nothing special, either, about the materials necessary to
do these projects. Everything we used is inexpensive and readily
found in art stores or in the five-and-ten. Some of the projects that
use a Polaroid photo we created immediately after taking the picture
to show how easily you can make a last-minute present on Christmas
morning when all the stores are closed.

We hope that our ideas will encourage you to be more creative
in your picture-taking so as to fit your photos to a particular craft
project, or to expand on something included here that appeals to
you. We think you will find as we did that much of the fun of creating
these projects comes from working with photographs of people you
know. In our case, we hope our friends and family will like the way
they have been re-presented.

Cutting and Mounting

Materials

Almost all the projects in the book require the same materials. All are available where art materials are sold.

Mat Board is used for matting or mounting artwork, prints, and photographs. The sheets lie flat and cut smoothly without pulling or fraying. They come in black and white as well as in a variety of colors. The size is 32 by 40 inches and the cost under three dollars apiece. Smaller sizes are often available.

Mounting Board is an inexpensive, rigid white board for making models, signs, and posters.

Illustration Board is made of high-grade white stock. It is finished on both sides and is available in a smooth and slightly grained finish. It comes in different sizes and the price varies accordingly.

Foam Core is a rigid, lightweight graphic-arts board made from polystyrene foam sandwiched between high-quality paperboard. It cuts easily with a razor blade or craft knife. It is an excellent substitute, where thickness is required, for the standard framing technique to mounting a photograph.

Corrugated Board comes in double and triple wall thicknesses. It is made of rigid but lighweight paper and is excellent for mounting. The sheets are approximately 30 by 40 inches and range from sixty-five cents to around two dollars.

Construction Paper is traditionally found in the five-and-ten or stationery stores. For fine-quality construction paper, art stores sell a package for around a dollar fifty to two dollars and it is available in red, green, white, brown, black, yellow, orange, and assorted packs. There are fifty sheets to a package.

Charcoal Paper is made of cotton-fiber paper. It is effective for use with markers and paints because of the consistent quality of the surface and substance. You can purchase one sheet for about a

quarter, or a package of one hundred sheets. Each measures 19 by 25 inches.

Cover Stock has strength and is excellent for photo-album pages as well as for covers. It comes in a variety of colors but black and white are the easiest to find.

Blank Greeting Cards can be purchased with matching envelopes for creating your own designs. They measure 5 by 6 7/8 inches and are packaged twenty cards and envelopes to a box. There is a wide assortment of colors to choose from.

Wallpaper can be used as mounting background for a photo, to line a box, or to cover an inexpensive frame. You don't have to order a lot of rolls. Ask at your local wallcovering dealer for a sample book of styles they may have discontinued. This will provide you with enough of a selection of small pieces to use when needed.

Wrapping Paper is available in wonderful designs, themes, colors, and so on. Spend some time selecting the background that best enhances your photograph.

Fabric is another background material used extensively for mat covering. Buy small remnants when they are available in fabric shops. In this way you'll always have a good number to choose from when you are ready to do a project.

Tracing Paper is the number-one necessity for doing all the projects. Have enough on hand for all your crafting needs. You can buy it in sheets, rolls, or on a pad.

Cutting

Cutting is an important part of mounting your photographs. While it isn't difficult, precision is important and your tools should be sharp. If you have the necessary equipment it will be easy for you to do any of the projects like a professional.

Single-Edge Razor Blades are worth buying by the box. These are a must to have if you will be doing any precision cutting.

Craft Knife can be used in place of razor blades for most projects. Some, like the Stanley, have a retractable blade; others, like the X-Acto, are small and easy to handle for delicate artwork. The blades are replaceable for both and come in different sizes.

Utility Saw is a small hand saw for light woods and cardboard.

Mat Cutter is a tool for the foolproof cutting of picture mats. It will enable you to make perpendicular as well as beveled cuts. It is easy to operate, comes with instructions for use, and ranges in cost from six dollars to about fifteen dollars.

Scissors are important, although most of the cutting and cropping of photographs is done with a razor blade or craft knife. For trimming and silhouettes, cuticle scissors are helpful. It is important that they be clean and sharp, and that they be used for cutting either paper or fabric, but not both.

Straightedge insures a perfect cutting line. This is usually a metal ruler that is strong yet lightweight and easy to handle. It is almost impossible to do any of the photographic mounting projects without this tool. It is indispensable.

Triangles, used for drafting, come in different sizes and are made of transparent acrylic plastic. The inside edge is beveled to make it easy to set down on and lift off of your work, and it will aid in cutting the work squarely. There are two types of triangles: one is 30 by 60 by 90 degrees and the other is 45 by 45 by 90 degrees. They are usually called either a 30-60- or a 45-degree triangle. The octagonal matting project at the end of the book employs a 45-degree triangle.

T Square is used to keep things parallel and at right angles. You can get an inexpensive one for around two dollars, fine for these craft projects, or a better one for between five and ten dollars.

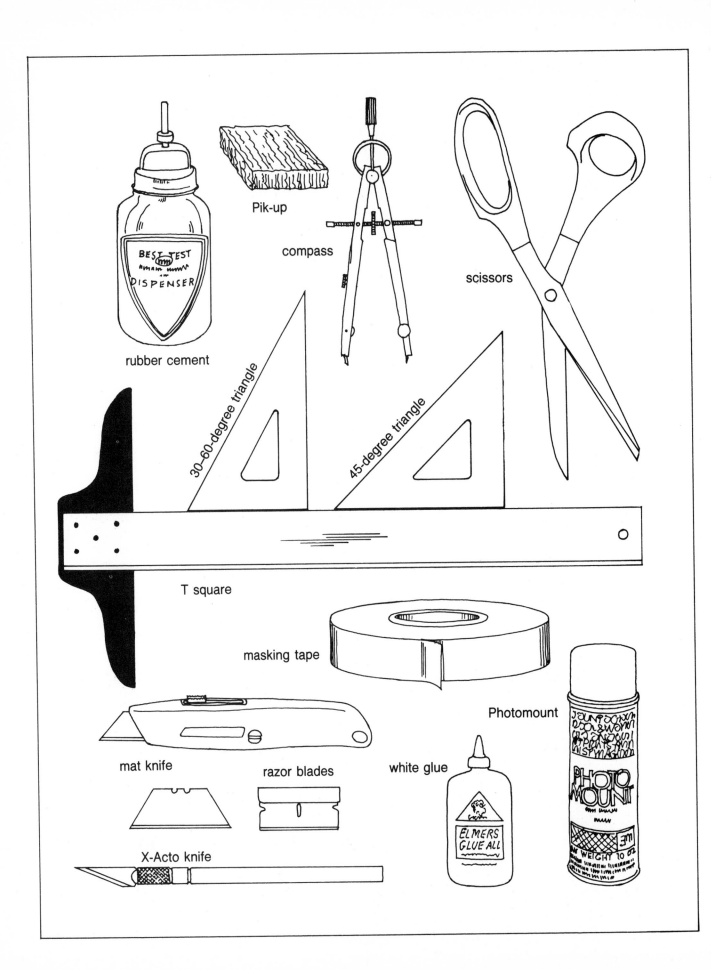

rubber cement

Pik-up

compass

scissors

30–60-degree triangle

45-degree triangle

T square

masking tape

Photomount

mat knife

razor blades

white glue

X-Acto knife

Mounting

Once you have become accustomed to using the tools of this trade and have learned how to cut with precision, you will want a clean, neat mounting job. This too depends on the materials you use, and how you handle them. Too often a project doesn't turn out exactly as it could have because the wrong material was used. The following are easy to find and can be used by anyone.

Rubber Cement is suitable for every paper-joining need. It will enable you to mount photographs neatly with no curling, wrinkling, or shrinking. While you are purchasing the rubber cement you should also buy a small can of solvent, which is used for thinning and for removing what you've mounted, if you make an error.

Pik-Up, a rubber eraser, is used for removing the rubber cement from the areas surrounding the photo once it has been mounted in position.

Glue is the generic word for many different products. For most of your crafting needs white glue is best. Elmer's Glue-All dries clear, sets fast, and holds well. It is used for wood, paper, cloth, and all porous materials. Elmer's Arts and Crafts Glue remains flexible even after it sets, dries crystal clear, and is good for fusing light-weight materials together.

Masking Tape can be purchased in different widths and is a natural-colored crepe-paper tape used for various general purposes. The photographs we matted were all secured to the background with masking tape.

Double Stick Tape is sticky on both sides and is used in matting projects.

Spray Adhesive made by 3M is a strong, translucent adhesive for bonding paper, foil, cloth, cardboard, and foam without wrinkling. It dries quickly for permanent or nonpermanent bonds. The brand name is Spra Ment.

Photo Mount Adhesive is also made by 3M and is a product developed especially for mounting black-and-white or color photographs quickly, easily, and permanently. This can also be used for the travel mural and collage projects (p. 104). It comes in a spray can.

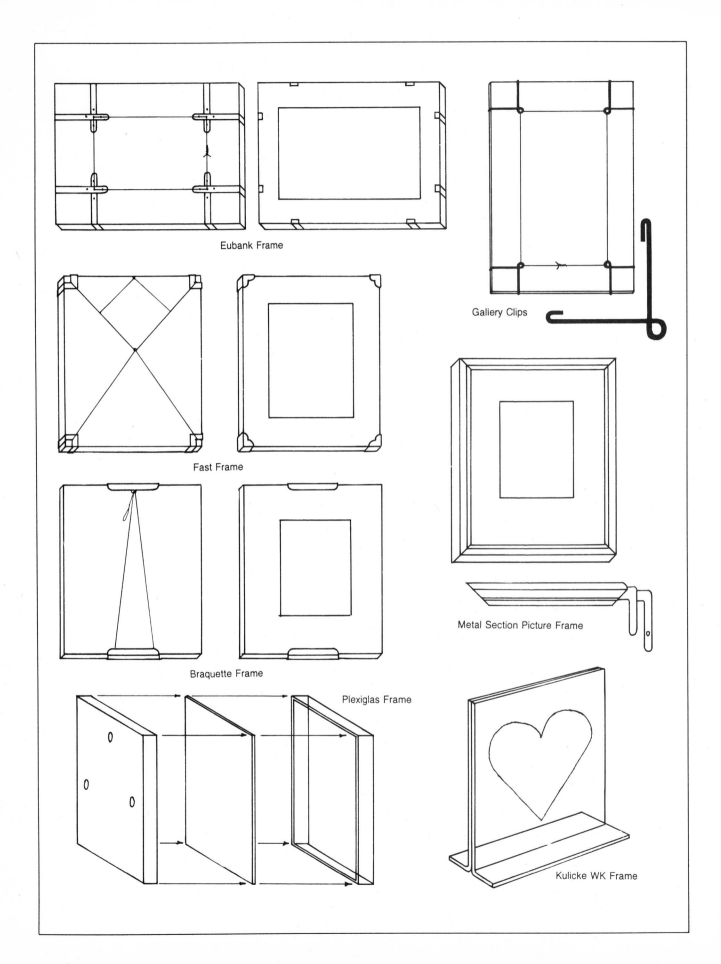

Eubank Frame

Gallery Clips

Fast Frame

Metal Section Picture Frame

Braquette Frame

Plexiglas Frame

Kulicke WK Frame

Frames

Frames come in every conceivable size, shape, and material. Some that you may be familiar with are the following:

Plexiglas Frames consist of a plastic casing into which a rigid cardboard filler box is inserted to hold pictures flat. They will stand alone or can be hung.

Metal Section Frames are for the do-it-yourselfer and are simple to put together in any size you need. They come in chrome or gold finish and are sold with the necessary hardware and instructions all packaged together.

Braquette Frames are strong and adjustable with a spring-tension nylon cord that fits pictures up to forty inches high. They are designed to make it quick and easy to change pictures.

Kulicke WK Frame is ideal for displaying two sided pictures. It is a freestanding clear acrylic stand that presses the picture flat.

Easel Backs are gray die-cut cardboard backings that attach to the mat so that the picture can stand alone rather than be hung. They are available in both double- and single-wing versions and are quite inexpensive. However, they are not always easy to find. A pattern for making your own is included on page 73.

Eubank Frame is a framing system that holds pictures equidistant from the wall on all four sides. It creates the effect of a picture "floating" in space. Best for larger photos.

Fast Frame is a tension system using plastic clips at each corner of the picture.

Kulicke Trap Frame is a transparent frame that creates the effect of the print suspended in air. The picture is sandwiched between sheets of clear acrylic. The edge of the frame is a thin band of polished aluminum.

Quick Stick Hangers are the simplest and least costly way of all to hang a light weight picture. After peeling off the liner, you press the hanger onto the center of the picture, burnish it down, and hang it up. These really hang on tight.

Gallery Clips are unobtrusive little metal clips designed by a photographer to hang flat photos with glass and backboard.

Stamp Act

It is very easy to obtain stamps depicting almost any subject you are interested in. Many of the stamps from around the world are beautifully designed and can serve as a border for an appropriate snapshot. This montage was inspired by stamps of such famous women of the world as Madame Curie, Princess Grace of Monaco, Amelia Earhart, and others. The stamp companies package stamps on boats, sports, flowers, states, and various other subjects and they cost as little as ten cents a package. Stamp catalogs list the various subjects.

To turn your little girl or favorite woman into one of the famous women of the world, begin with a colorful 3 1/2-by-3 1/2 inch photograph. Cut it so that it is the shape of an oversized stamp of whatever size you desire. Cut an index card a quarter inch larger than the photo on all sides. Using a paper punch, make half circles all around the edges of the index card to give it the appearance of a postage stamp. Glue the photograph to the card.

Black poster or mat board can be used for the background. Construction paper is thinner, but can be used as well. If you prefer another color for the background be sure that it contrasts well with the stamps you have chosen. Black usually offers the most dramatic setting for this project.

Place the photograph stamp in the center of the background and arrange the stamps around it, moving them until you have a pleasing arrangement. Glue everything to the background with rubber cement. Do not attach the stamps by licking the backs as they will not stick as well. Also, by using rubber cement you will, if you place one of the stamps in the wrong position, easily be able to remove and reposition it. This project can now be framed or mounted to the wall with self-adhesive tabs.

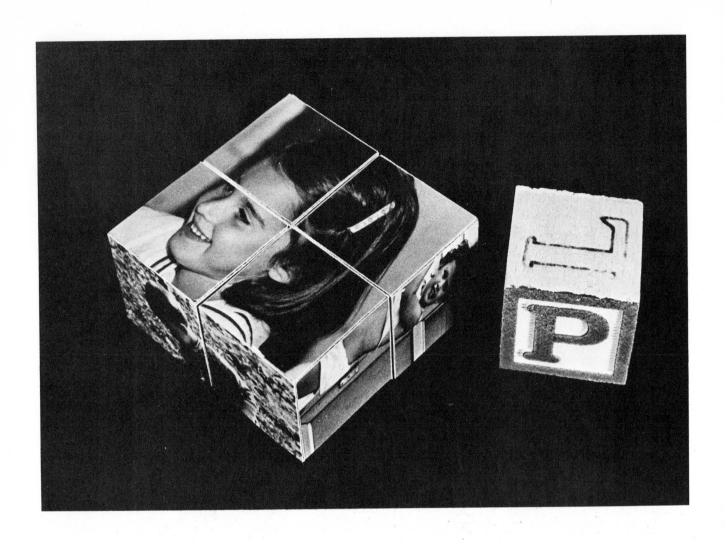

Photo Cubes

These photo cubes, as well as being a way to display a variety of photographs on a table, form a puzzle. The idea incorporates six related snapshots. They can be any size. You might use pictures of your child growing up, or pictures of several children, or of your entire family, or pictures of events, or of places you've visited.

Four ordinary wooden blocks commonly found in the five-and-dime are used. They measure 1 1/4 inches. Even though these blocks aren't always absolutely smooth, often having embossed letters on two sides, the photographs do appear to be flush when they are mounted. While this project is quite easily done, accuracy is important.

Begin by applying rubber cement to the back of each of six photographs of the same size, and to one side only of two blocks. Let the rubber cement dry. Each picture must be cut into four squares, each one exactly 1 1/4 inches square. Do not try to mount the entire

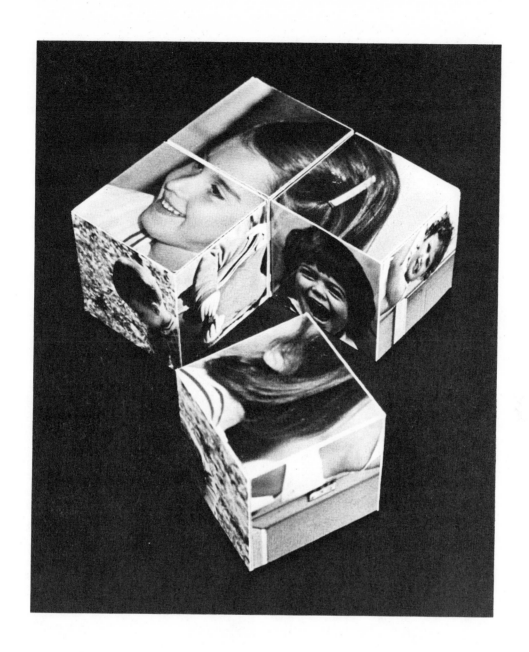

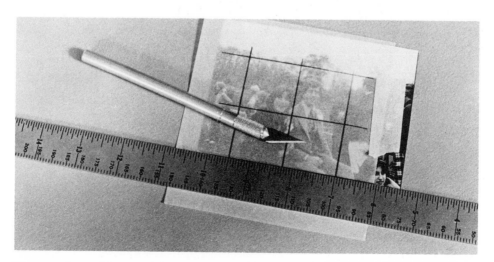

Use a tracing guide to compose the photo for cutting.

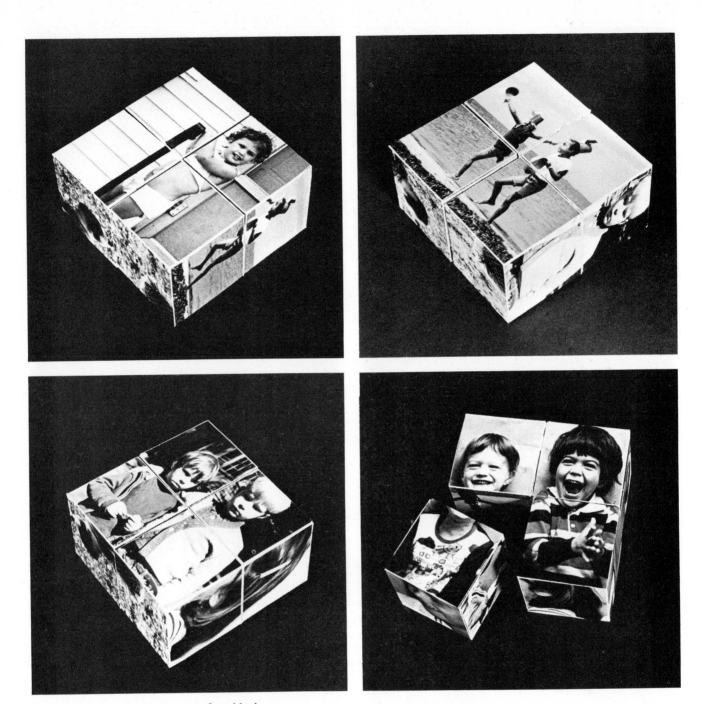

You will use six photos to cover four blocks.

picture on four blocks and then cut them apart. This will result in a crude and inaccurate finished project.

With a piece of tracing paper, ruler, T square, and triangle, draw the outline and the cut lines for the photograph. Position the tracing over the photo in order to compose it properly. (See diagram.) You want to avoid cutting through someone's head or having the cut line awkwardly placed. Position the tracing-paper outline where it looks best on the photo. Tape the tracing paper in position on the photograph. Using a sharp razor blade or craft knife and straightedge, cut through the tracing paper and photo. Repeat this on all six photos. You will have four squares for each side. Cut and mount one photo at a time. (Do not apply the rubber cement to all sides of the blocks at one time as they'll stick together when you are working.) Apply the rubber cement to the top of the four blocks to be mounted and let this dry before proceeding.

Once the first four sections of a picture are securely mounted, turn the blocks to the next surfaces. Repeat this process of positioning, gluing, cutting. When you are finished you will have four blocks with parts of a photograph on each side. If you use glossy photographs the blocks will have a shiny, finished look as though they have been varnished. Use a razor blade to trim the edges if necessary.

This project can be made with more blocks and larger photographs; however, when starting, four blocks are recommended.

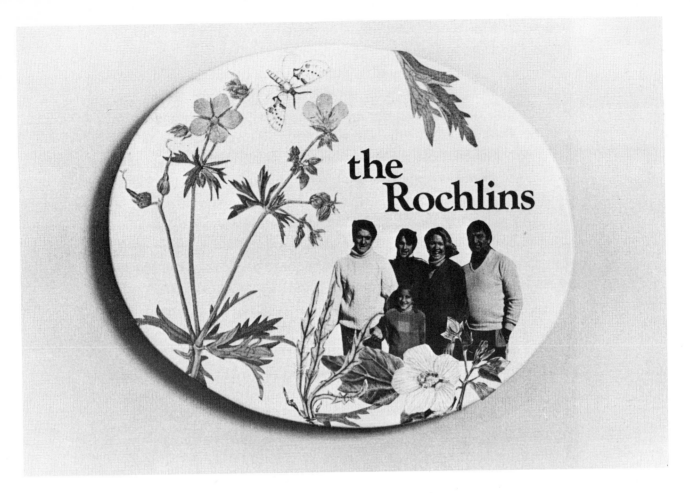

Address Plaque

An address plaque is the perfect housewarming gift. If you have a picture of a family or last year's Christmas photo card you can make this easily. Have the plaque cut to size at a lumberyard. (You might, however, find such an item at the craft store.) If it becomes difficult to find an oval shape and you don't have access to a saber saw to make it yourself you can use a square or rectangular piece of wood. These are more readily available.

The crafting technique used here is decoupage, which means applied cutouts. No drawing skills are required, simply the ability to cut out the designs from paper. Begin by sanding and painting the wooden background. You can use water-base paint such as latex wall paint or acrylic in the color of your choice. The acrylic paint comes in small tubes found in art supply stores. When the paint dries, sand the surface lightly and apply another coat if necessary.

Choose a design that suits the shape of the background and photograph to be used. You can cut the design from greeting cards, wrapping paper, a book, posters, or similar material. Magazines are too thin and the paper will tear and wrinkle when glued down. You

might even consider using pressed flowers for this project. Cut the paper designs out and arrange them on the plaque, adding or cutting away where necessary. Glue them to the painted background leaving room for the photograph and the name. Next, cut away the excess background from the photograph so that you are left with a silhouette of the subjects. Place it on the plaque but do not glue down until you have designed the name into the overall pattern. The name will look as if it had been painted or printed on the plaque if you use press-on letter transfers. These are found in art stores and are easily applied by rubbing them onto the surface. They come in different sizes and typefaces and you will be able to select the right size and design for your plaque. With the photo in place figure out where the letters will go. Draw a guideline in pencil before applying them. The photograph can then be glued to the plaque. For best results, since the photo paper is fairly thick, use white glue such as Elmer's. Once the photo is glued down, pat away the excess with a damp sponge. You might feel that a few extra design cutouts are needed to overlap the edges of the photo so as to soften the cut

Mount cutouts with white glue.

Apply press on letters with a blunt burnisher.

areas. If you feel creative, try making a scene with flowers and people sitting or standing amid the natural setting.

When all the paper elements are attached, coat the entire surface with polyurethane varnish. This is a plastic resin found in hardware stores; when several layers are applied the plaque will withstand the weather and can be displayed on any front door. Brush the polyurethane over the front, sides, and back of the plaque. Set this aside to

Cut with cuticle scissors.

Use cutouts to cover incomplete picture.

dry thoroughly; this will take twenty-four hours. Apply several coats of varnish in this way until the surface is smooth to the touch. After the last coat of varnish, sand the finish slightly and apply a coat of furniture paste-wax to protect it. The more coats of varnish that have been applied the more durable the plaque will be. Finally, a brass ring can be screwed into the top for easy hanging, or the plaque can be attached to a door with self-adhesive tabs.

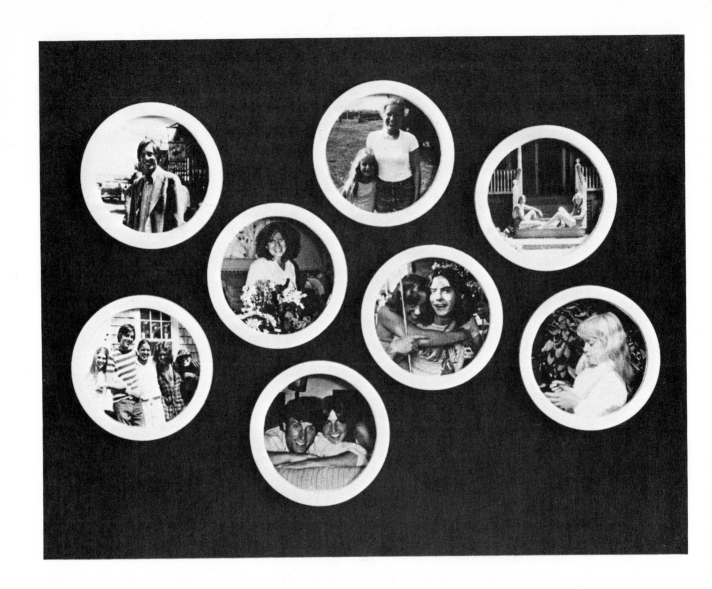

Coaster Frames

Inexpensive coasters can be found in the hardware or five-and-ten-cent store. They usually come eight to a package and the plastic border makes a perfect little frame. Sometimes they come with a foam-rubber inset which can easily be removed. These could serve as delightful souvenirs at a family gathering or be used as place markers at a party table. Each person might appear in a baby picture and it could be fun to figure out who sits where by identifying the photographs. If you want to paint the frames this can be done in minutes with spray paint, which comes in a variety of colors.

For this project we used eight related pictures. They all make up a theme showing one person in different situations. You might do this project with pictures of a child at different ages or a succession

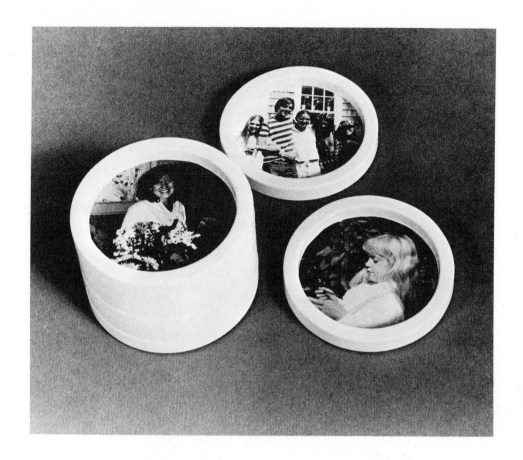

of pictures taken at a birthday party, graduation, or sporting event.

Using a compass, measure the inside diameter of the coaster. Draw this circle on a piece of tracing paper. If you don't have a compass use a water glass, jar, or can which is the exact size needed. Since coasters are made to hold glasses, chances are you will have a glass that just fits. Tape the tracing paper to the photograph. Position the circle over the section of the photograph that is most suitable. Carefully cut through the tracing paper and photograph along the circular line. Place the photograph in the coaster. If it buckles, remove it and trim slightly so that it fits perfectly. Glue the picture in place using rubber cement. When choosing several pictures select those that will look best when cut in a circle. By placing the tracing paper over the photographs you can see how they will look before cutting them. If the coasters are white, your pictures will look best if you choose those that don't have a lot of white background so you will have contrast between the photograph and the frame. Once you have made a grouping of several pictures, you might hang them side by side using self-adhesive tabs. Another suggestion is to attach them in a vertical row on a wide ribbon before hanging.

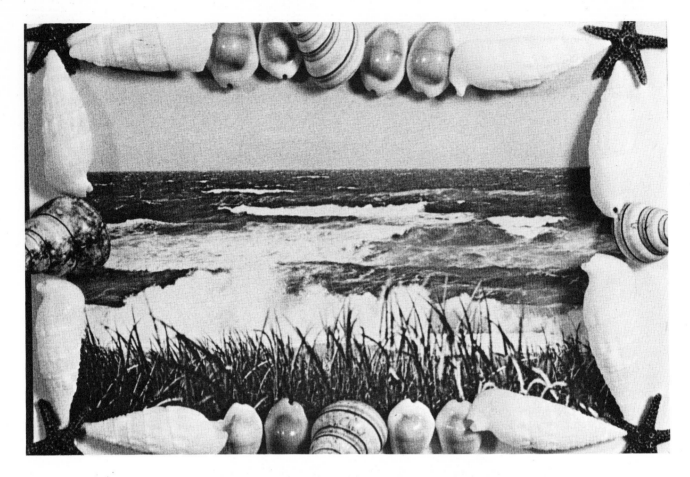

Seashells by the Seashore

Often a photograph depicting a scene suggests the kind of frame that would enhance it the most. In some cases, such as natural settings, the materials are readily available where the picture is taken. For instance, a picture taken in the woods can be framed with twigs. (See p. 42) A picture of a field of buttercups can be framed with pressed buttercups. In this case a visit to the seashore yields a variety of shells that are suitable for a frame. When on vacation think about this as you take your pictures so you can collect the necessary material.

Mount the photo on heavy cardboard leaving enough of a border for the seashells. Arrange the shells around the border in a pleasing way before gluing each one. Elmer's glue will hold the shells in place. You can fill the area heavily or simply make a border of decorative delicate shells. Starfish are used at each corner of the photograph here. If you haven't collected the shells and would like to make this project, you can purchase all kinds of interesting seashells through mail-order sources (see supply list). Let the shells dry on the background before hanging. For added luster varnish the shells with a high-gloss polyurethane.

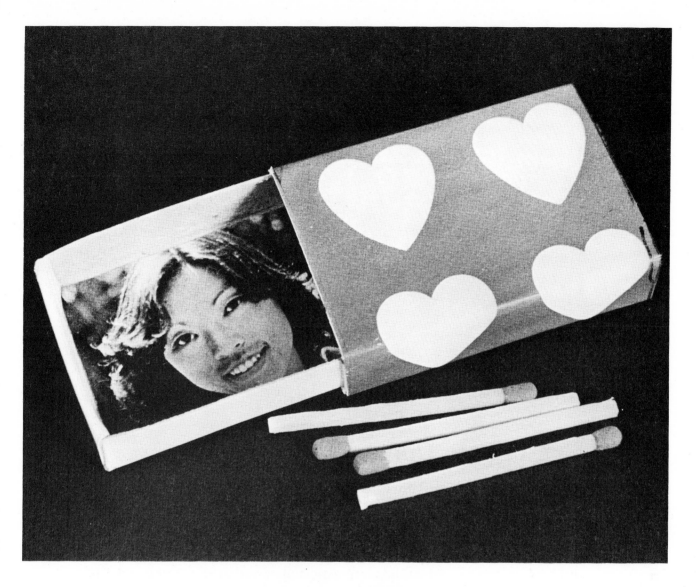

A Perfect Match

If Valentine's Day is coming up or you're just in the mood to send a remembrance of love to a friend, here's a small, easy gift that you can make in minutes.

Begin with a matchbox with a sliding cover. Wrap the outside with appropriate wrapping paper, Con-tact, or fabric, or use spray paint. In this case red-and-white valentine gift-wrap paper is used. If you are selecting fabric the pattern should be small and you only need the tiniest scrap. Spread Elmer's glue over top, bottom, and sides and attach the covering. Let this dry. To protect the paper covered box and to give it a shiny finish, coat the entire surface with clear nail polish. It will dry quickly.

Next select a picture of yourself that is the right size to fit inside the box. Crop the photo so that your head fits perfectly inside and glue this in place. Wrap the box in gift paper and tie with a bow.

Photo Concentration Game

Have you ever played the game of Concentration with cards? This is a variation of that game using photographs. It can be played at any gathering with friends or family and everyone will enjoy discovering pictures of themselves. Perhaps you have old baby pictures of each family member. Children are especially good at this game and in our family all members under ten usually win.

This project requires approximately twenty cards. You can use more or fewer, but twenty seems to be a good number. Begin by having two prints made from each of ten photographs. Mount construction paper to the backs of all photos so that each is identical from behind. Place all cards face down and mix them around so that you can't remember where they are. The first player turns any two cards over to reveal the photographs. If they match, the player keeps them. If they don't match, the player turns them face down exactly where they were. The next player takes a turn and so on until all the cards have been won. The player with the most pairs of cards is the winner.

Make these up to give as a gift. Create a card box to contain the mounted photographs and write out instructions for playing the game. This will be a much appreciated present for the entire family to enjoy. And it's less fattening than a box of candy!

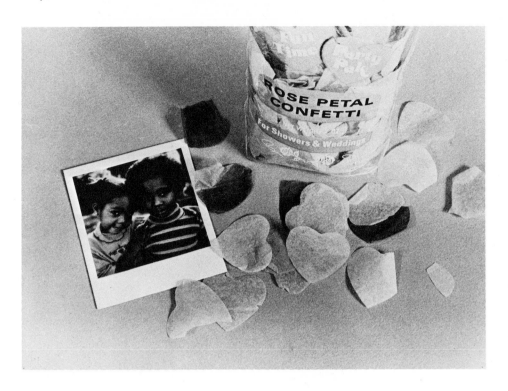

Petal Pretty

There are lots of good framing and matting ideas for photographs right in the five-and-dime. Polaroid SX-70 pictures need a frame and matting around them because they cannot be cropped. This colorful picture seems just right for a festive frame.

The 3 1/8-by-3 1/8 inch print used here is a Polaroid SX-70. The frame is created with tissue-paper rose petals. These come in a package and are sold as confetti to throw at a wedding. Because the petals are pastel and transparent they can be overlapped and placed at random with almost no preplanning. This makes the frame easy and fun to create in no time at all.

Begin by drawing a seven-inch square on a piece of stiff cardboard. In the center of this square draw a three-inch square. Brush rubber cement over the entire area of the seven-inch square. It doesn't matter if the rubber cement extends over the lines at the outer edges. If you don't have rubber cement, use diluted white glue. Next, lay down the petals in a way that is appealing to you. As you overlap the petals you will apply more glue or rubber cement. The glue will dry clear and the excess rubber cement can be rubbed away with your fingers after you are finished. Mount the petals so they overlap the pencil lines of both squares. In this way, when you cut out the squares you will have a neat design that doesn't seem choppy at the edges.

When the area has been completely covered with petals you will

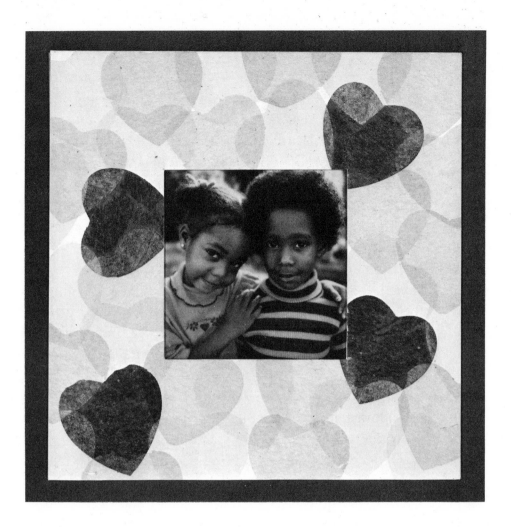

cut out both squares with a sharp razor blade and a straightedge. You now have a seven-inch square mat with a three-inch square picture hole.

To protect the finished frame and to give it a shiny look the matting is covered with clear plastic Con-tact paper. This is available in hardware and five-and-dime stores. Cut a piece of Con-tact so that it is slightly larger than the outer square. Lay the mat facedown on the Con-tact. Make a slit at each outside corner and fold the excess over the back. Make slits from the corners to the center of the smaller square and fold the Con-tact back. This will create finished edges around the outside and inside of the frame. The Con-tact covering will also keep the background from warping.

Next, tape your photo in position behind the mat and mount another piece of cardboard 6 1/2 inches square on the back of the mat to keep the photo flat.

You can now add a narrow frame to this or hang as is. This same technique can be used with ripped pieces of regular tissue paper if you can't find the petals. Simply tear odd shapes of different colored tissue and apply in the same way.

Beaded Border

Notions stores are good places to look for odds and ends to use for inexpensive framing ideas. There you will find unusual ribbons, buttons, snaps, sequins, and beads, as well as lace trimmings, rick-rack, and other materials used for sewing. Even a tape measure could be a cute trim for a specific photograph.

Tiny pearllike blue and pink beads come in small packages of two hundred for about sixty cents. Baby photos in pastel colors suggest a delicate frame and these baby beads are perfect. They are light in feeling, reflecting the daintiness of the picture.

Begin by trimming the photo and mounting it with rubber cement onto a backing. Select a pastel posterboard for the background. In this way the color will blend with the beads and enhance the project. Leave enough of a border all around for the trimming that will create the frame. This can be determined by experimenting with the beads to see how many rows will look best around your photograph.

Apply a thin line of glue around the edge of the photograph and set the beads down one after the other. If you use a white glue such as Elmer's, it doesn't matter if glue gets on the front of the beads because it will dry clear. It might be helpful to use a tweezer to place the beads, but isn't necessary. Once you start dropping the beads in place it goes very quickly. This frame is made up of three rows of beads. First, make a row of pink beads along the edge of the photograph. Next, set down a row of blue beads lined up alongside of the beads in the original row—not between them. Not every bead is the exact same size. However, you should try to place them side by side, if possible, to avoid problems at each corner. After setting the last rows of pink beads around the photograph you might have to trim the cardboard backing. This is best done with a sharp razor blade.

Hang the photo with self-adhesive tabs, or use a stiff piece of cardboard to make a tab in the back for easy standing on a table.

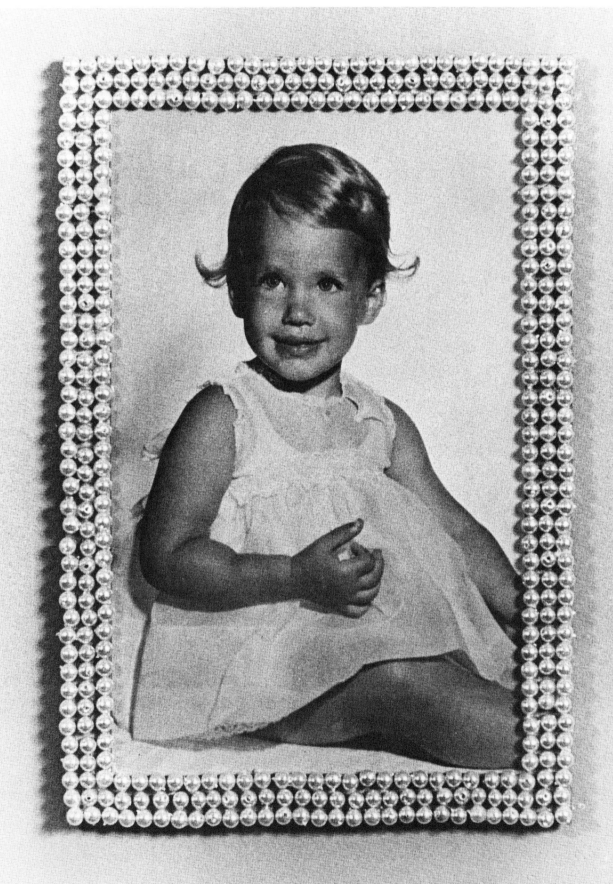

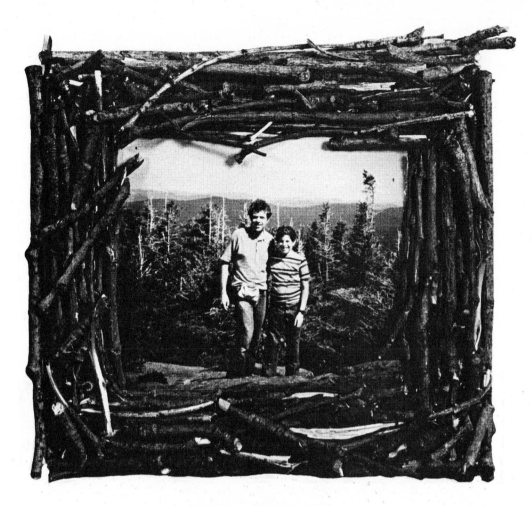

Twig Frame

Do you have a photograph of a camping trip or outdoor picnic? Perhaps you took pictures of your children at camp or standing in front of a scenic view. Sometimes a clever frame can turn an ordinary snapshot into a focal point of interest on your wall. Try twigs, pine cones, dried grasses, to enhance your photo. Children will enjoy collecting the materials and this could be a good scouting project.

Begin by collecting very thin, small, brittle twigs. Mount a photograph on a piece of wood or heavy cardboard. Leave at least one inch all around. Squirt white glue around the border and begin to add the twigs to the backing. Break them into pieces to fit. Keep adding glue and piling the twigs on top of each other to form a frame. The glue will dry clear, so keep adding enough glue to hold the twigs.

Let the frame dry overnight before hanging. Use picture wire, or attach a hanging tab to the back. For a shiny finish the twigs can be varnished, or darkened with stain. For a fast-drying, easy finish, coat the twigs with clear nail polish.

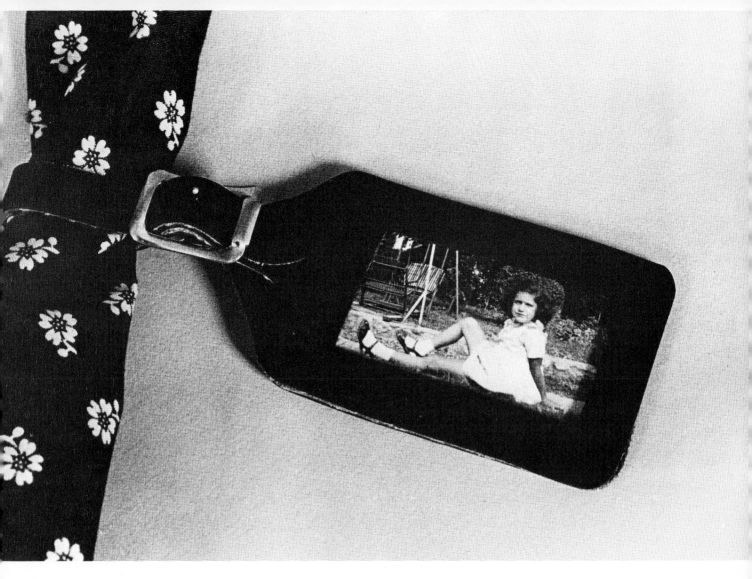

Tagged

To guarantee identifying your own luggage when you travel you might try inserting your photo into the luggage tag. This is a good little bon voyage present for someone going on a trip. However, we found another use for this idea. For a reunion party you can dig up photographs taken of classmates when you were in school. We all have old school photos tucked away in albums or boxes. Use these identification tags as napkin holders, or simply put them in front of each place setting and watch the fun as all the guests identify themselves. For added fun write something about each person on the back of his or her photo: vital statistics, hobbies, a long forgotten nickname.

Thanksgiving or Christmas are times when most families get together. For occasions like these, here is another way that you can have some fun with old photographs—in fact, the older the better. Insert baby pictures of members of the family into individual tags and use as place cards. This is guaranteed to be a conversation piece at any holiday gathering.

DATE _____ ASSIGNMENT _____ FILE NO. _____

Senior Powder Puff Football
Staples High School

35mm negative and title panel in plastic negative holder

A Contact Picture Story

A continuous story told on one roll of film and displayed in sequence can be more interesting than individually printed photographs. You might want to have a record of a sports event, a birthday party, or a wedding. This is an interesting way to keep one. The project shown here was made from a contact sheet made of pictures taken at the annual Powder Puff football game. One roll of 35mm black-and-white film was used, and pictures were taken from the beginning of the game right through to the end. There are shots of different plays, of the coach talking to the team, intermission activities, expressions on the different players' faces, of the losing team and the winning team.

When your prints come back the negatives will be in strips of four or five. There are inexpensive plastic negative holders available in camera shops. Place the negatives in the plastic strips, arranging them the way you want. Eliminate a few in the beginning to make room for a title. For this you need press-on letters and clear acetate. The press-on letters are available in art supply stores and can easily

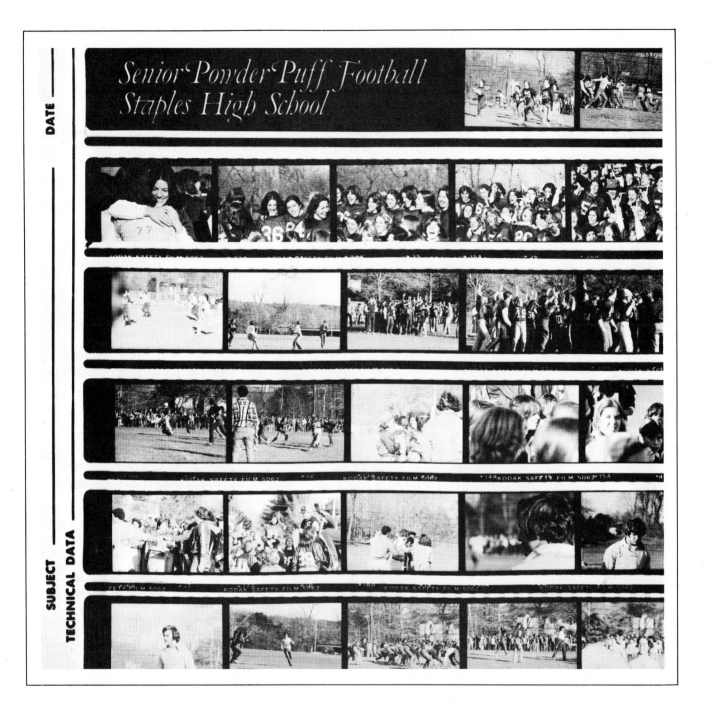

*Senior Powder Puff Football
Staples High School*

be rubbed onto the acetate to create a title. Cut the acetate so that it is in a strip that will fit into the negative holder.

Take the whole thing to the camera store to have a contact print made. This will be printed so that the size of the prints are the exact size of the negatives. When the contact sheet comes back to you it will have the negative numbers and manufacturer's name printed in white on the black background, under the photos. This gives the print a "behind the scenes" quality and can be framed as is.

If you want to identify the photos, captions can be written or typed on white pressure sensitive labels and placed under the photos. You can also add captions by using white ink on the black photographic paper. This is sold in art supply stores.

Color contact sheets are available as well. They are made from 35mm color negative film such as Kodak's Kodacolor II. It is necessary to ask your camera shop or laboratory if they provide this service as it is not available everywhere. Color contact sheets are more expensive than black and white. However, the effect of a color contact sheet is most impressive. The colorful pictures are set against a jet black background. For a wedding gift idea consider taking a roll of pictures at a friend's wedding.

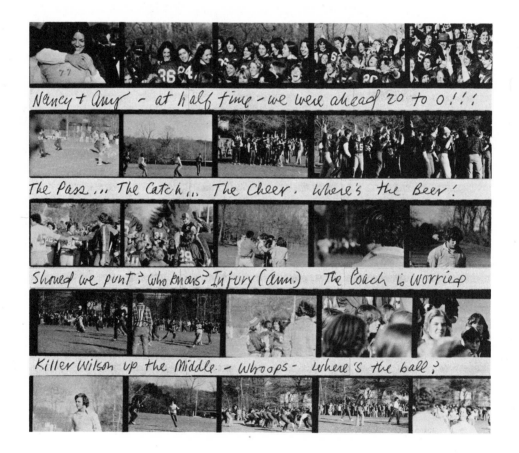

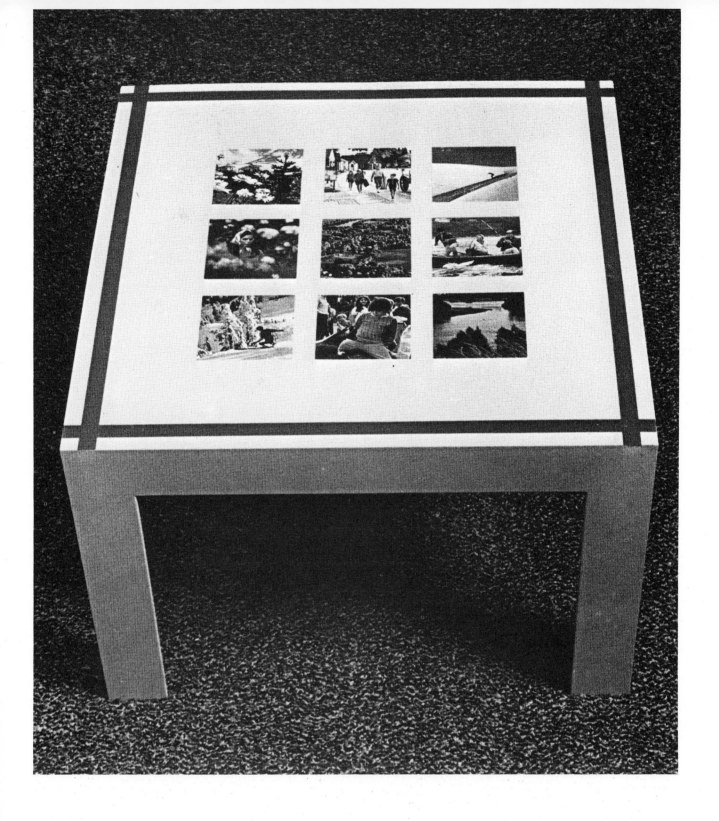

Tabletop Montage

Decorate a tabletop with photographs of a recent vacation, wedding in the family, or a series of photos showing your children at different ages. The snapshots should be trimmed so they are the same size. If you mount the pictures with adhesive mounting sheets you can change them from time to time. If you glue the pictures

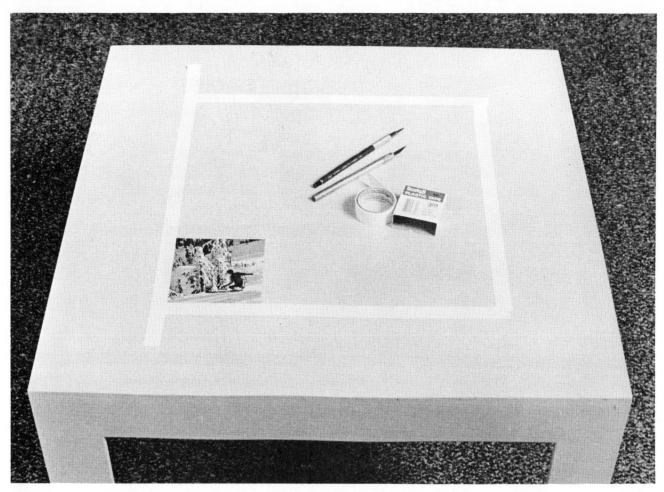

Masking-tape border serves as a guide for positioning photos.

down with Elmer's or another white glue they will be permanently bonded. This project was done on a plastic Parson's table which seems perfect. If you have an old table, spruce it up with some paint and add the photo decoration to give it a new life.

Determine how many photos you will need for the area to be covered. Measure and make light pencil lines for a rectangle of masking tape around each photo. Lay the tape in position. This will enable you to put the pictures accurately in place. Apply rubber cement or adhesive mounting sheets to the back of each photograph and place the first one in the left-hand corner on the table. Work in from each corner, placing the center photos down last.

Lay a piece of tracing paper over the photos and rub your hand over them to be sure they are secure. Remove the tape which was used as a guideline. To give the table a finished border, outline the edges with a colorful plastic tape such as Mystik by Borden's. Lay

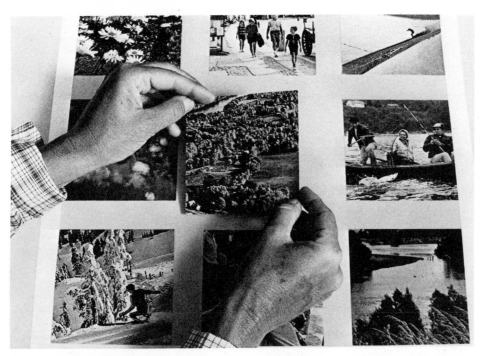

Mount center photo last.

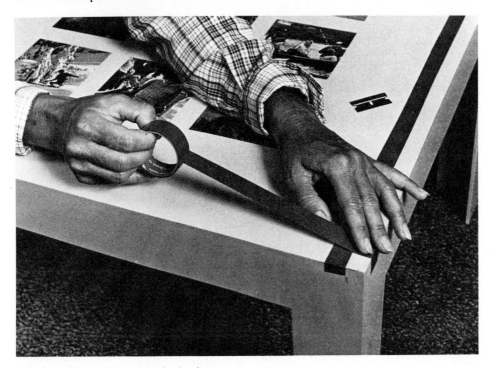

Overlap tape at corners and trim later.

the tape on the table so that it overlaps at each corner. Using a straightedge and sharp razor make mitered or diagonal cuts so that the corners butt and join perfectly. Peel away the extra layer of tape at each corner.

To protect the photographs add a coating of polyurethane varnish or have a glass cut to cover the tabletop.

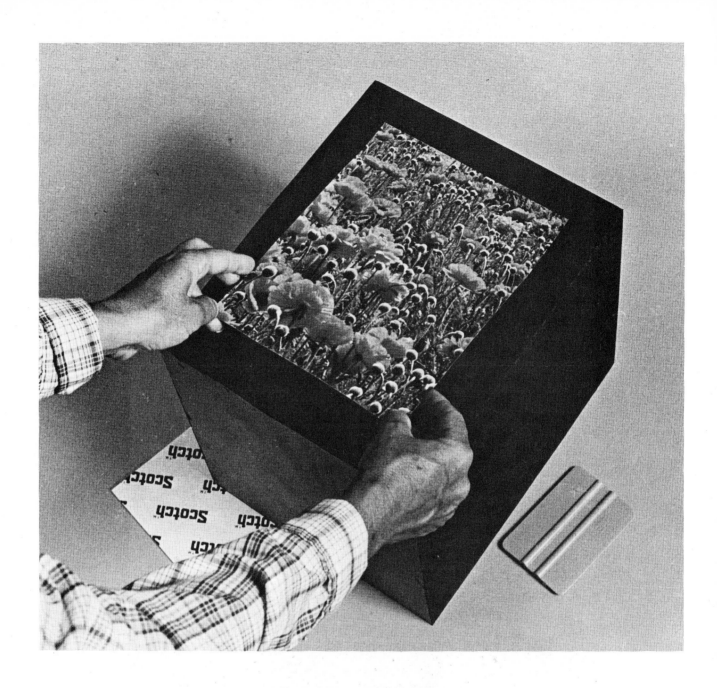

Scenic Planter

If you have taken a scenic photograph that you'd like to display, have it enlarged and mount it onto a planter. The size of the photograph will depend on the area to be covered. Try to select a plant holder that is no bigger than 8 by 10 inches. The one used here is made of redwood and a trip to any plant store will yield a variety of containers to choose from. You might also try an unfinished furniture store outlet for wooden cubes that are made for storage. These can be lined and used as planters. For outdoor use the finish will have to be coated with polyurethane after the photograph has been mounted.

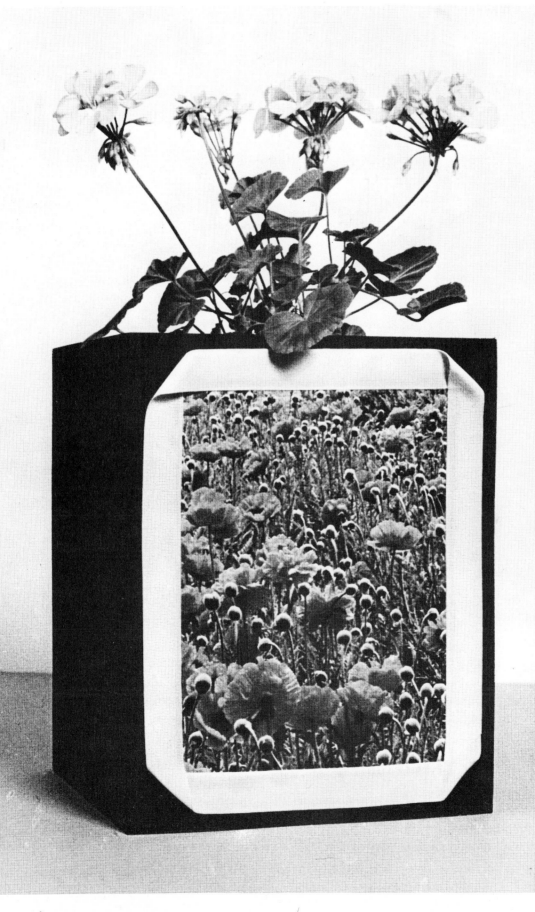

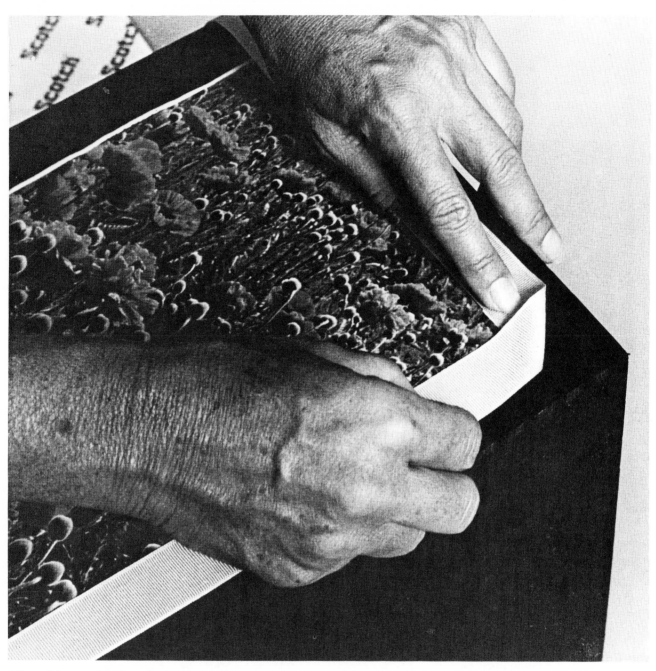

Allow ribbon to fold loosely at corner.

Paint the wooden planter with water-base paint such as latex or acrylic. The acrylic paint comes in tubes and can be found in art supply stores. The colors are brilliant and may need toning down with white paint. When dry, sand lightly.

Crop and mount your photograph to the object. Next, apply a thin line of white glue around the edges of the picture. Start at one corner and lay down a band of one-inch grosgrain ribbon, turning it under at each corner. The ribbon will be one continuous piece, creating a frame for the photograph.

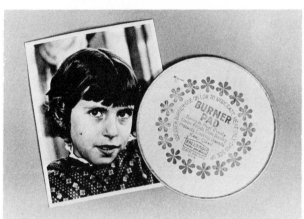

Hot Plate Frame

Many ordinary items that we see every day can be turned into inexpensive framing ideas. The important thing is to keep an eye out for them and to have an open mind about their uses. It's just a matter of looking at utilitarian things in order to get an idea or two. Before throwing something away look at it with this in mind and perhaps it can be recycled for another use.

This hot plate is just an asbestos disc with a metal frame. It was used and burned, but the rim is perfect for a frame to hold an 8-by-10 inch photograph cut into a circle. The metal rim can be used as is or, as here, spray-painted. Choose the color you want and it will take just minutes to perk up the rim. For a black-and-white photograph, a black rim will contrast well. Hang with self-adhesive tabs attached to the back.

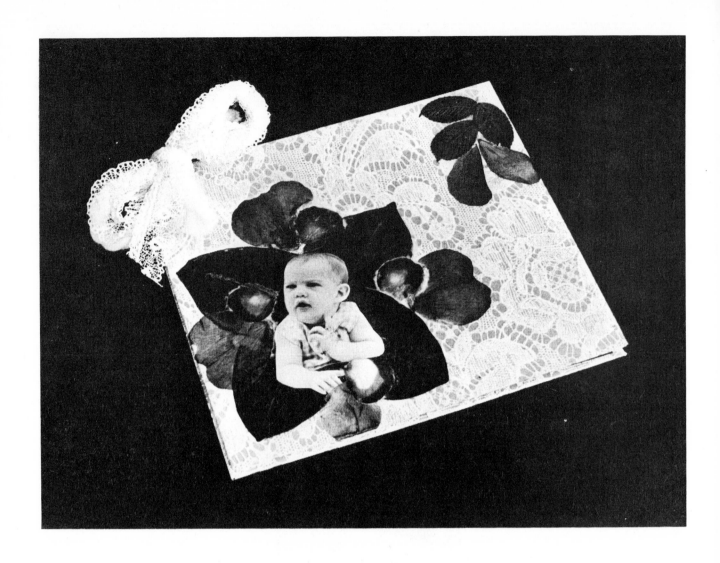

Petal-Precious Album

While there are delightful baby photo albums that can be purchased, they are often expensive; by making one yourself you can personalize it. The design on the front of this one was created with pressed leaves and rose petals pasted around the baby's picture. If roses aren't in season in the garden, you can purchase one rose from the florist and you will have enough petals to do the job. The background is tablecloth plastic which you buy by the yard in the five-and-dime. This one has an overall lacy print.

To make this album you must begin a week in advance by pressing the flowers. It's important that they be thoroughly dried out before they are used. Pluck all the petals from the stem and place them on clean paper, newspaper, or paper toweling. Cover them with another piece of paper and pile heavy books on top. Leave undisturbed for at least three days. The paper will absorb the moisture in the flower and the color will remain brilliant after the petals are dry.

Determine the size of the album you want to make. This one is 7 by 8 inches. Your size will depend on the photographs that you have on hand. Cut two pieces of heavy posterboard for the front and back. Coat one side of each with rubber cement and set aside to dry. Next, cut the plastic (or you can use wallpaper or fabric) slightly larger than the cardboard. Since this is clear plastic with a white design we decided to back it with pink construction paper to create a white-lace-on-pink effect. Cut two pieces of construction paper, each slightly larger than the cardboard. Coat the back of the construction paper with rubber cement.

When dry, mount the construction paper onto the front of the album cover, then onto the back. Put rubber cement on the back of the plastic and mount this over the construction paper in the same way. Turn the whole thing over, clip the excess paper from the corners, and fold in to finish the edges. Tape the plastic to the inside or back of each piece of cardboard.

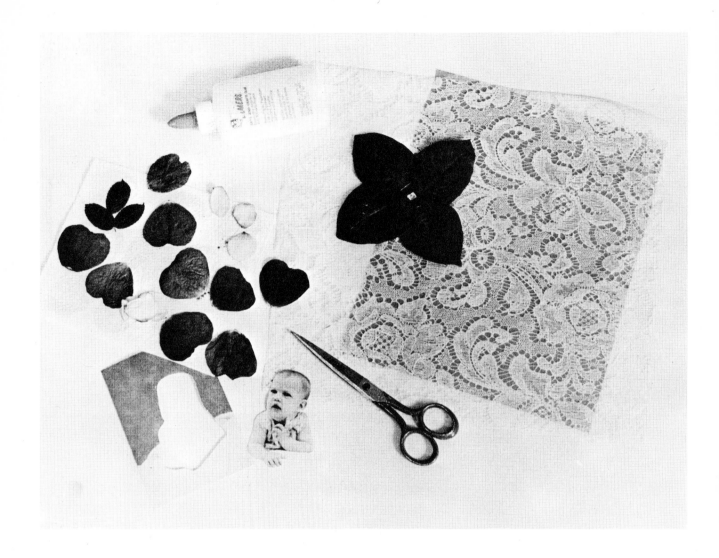

Next, cut two pieces of matching paper or fabric slightly smaller than the cardboard front and back covers. Coat the back of these with rubber cement. When dry, mount each to the undersides of the two pieces of cardboard. This will finish the inside, covering the taped edges, and adding interest when the album is opened. If you prefer you can mount a full-size photo, cropped to size, onto the inside flap.

Now it is time to arrange the flowers and baby's picture on the cover of the album. Cut out a silhouette of the new baby from a photograph. Arrange the pressed leaves and petals so they form a frame around the baby's picture. Use white glue to tack the picture and petals in place. Use only a small amount to do this. Handle the pressed flowers carefully so they don't tear or stick to your fingers and rip. They are very delicate.

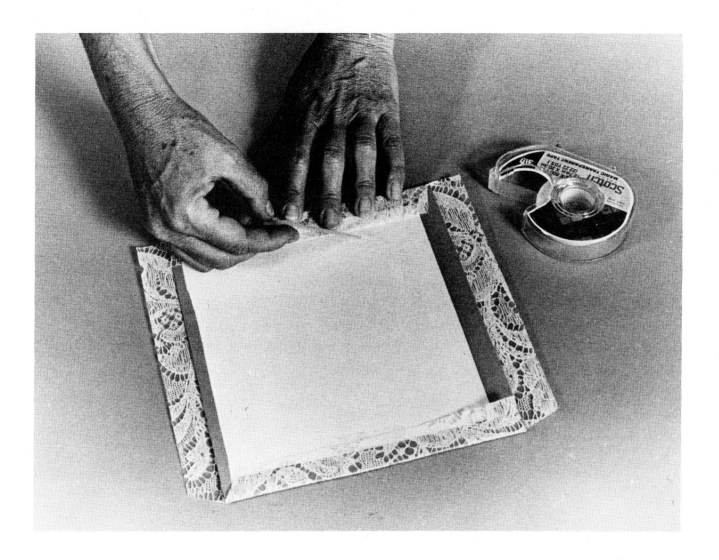

Cut a piece of clear Con-tact paper so that it is larger than the album cover. Lay it carefully over the photograph and flower petals. Smooth it down. This will protect the design elements. Trim away the excess Con-tact around the edges.

Next, cut pages of black construction paper slightly smaller than the album covers. For a colorful album you can make each page a different color, but black is generally a good background for most pictures. Stack them between the album covers in order to position them. With a paper punch, make corresponding holes in the top corner of the pages and cardboard covers. Use a pretty ribbon or thick yarn to tie the album together. The pages can be viewed by fanning them apart or by lifting the cover.

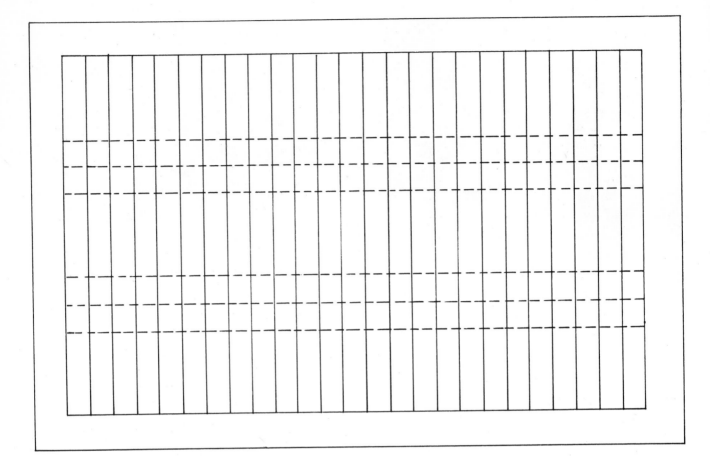

Photo Wreath

Traditionally, a Christmas wreath is hung on the front door. However, this personalized wreath made up of family photographs serves as a unique indoor decoration.

Begin by cutting a disk ten inches in diameter from posterboard. Next, cut a five-inch diameter center hole. The decorative frames are all black and white, and color photographs are used overall. We have included here a group of frames you can use to create your wreath. Make Xerox copies or photostats for your own use. This relatively inexpensive service is available at copy centers, listed in the Yellow Pages of your local directory. We have provided ten borders, but the wreath is made up of twenty pictures so to do this exact project you will need two photostats.

Once you have your frames assembled, cut the center areas out of each. Assemble all your photographs and match them to the frames by laying the frame over the photos to see which looks best with which. After selecting the photos, trim each to fit the frame and tape it in back with Scotch tape.

Next, arrange the framed photos on the background disk. The pictures must be positioned so they don't cover each other. At the

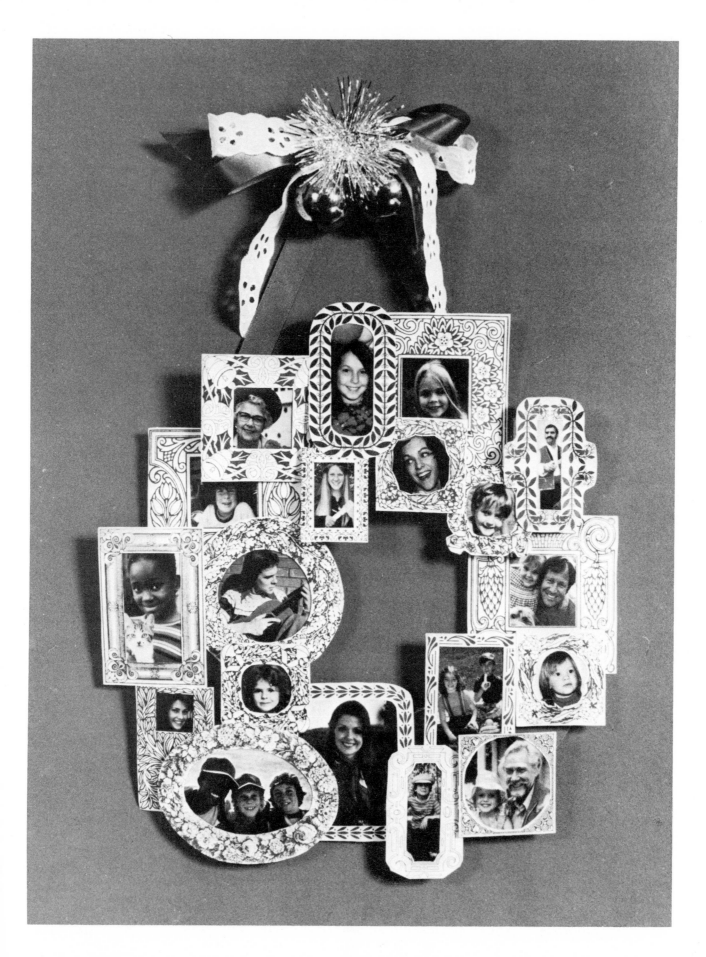

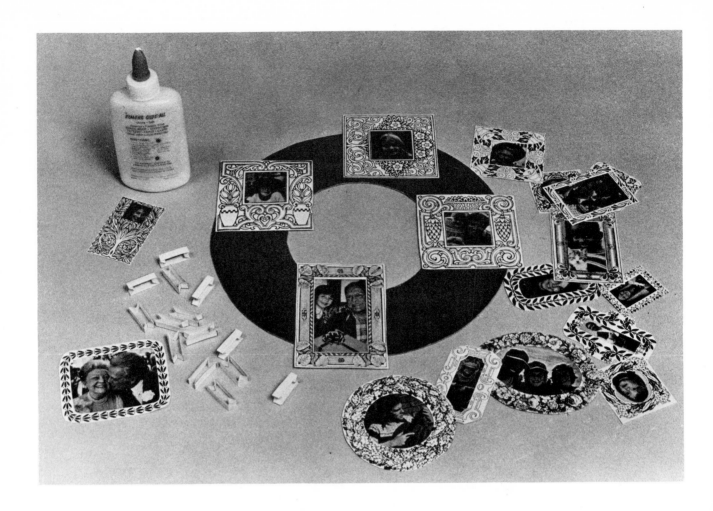

same time they must all be affixed to the background disk. Once you have a pleasing arrangement, you are ready to mount the pictures to the background.

The three-dimensional effect is created with paper hinges. Copy the diagram on stiff paper. With a straightedge and a ball-point pen, score the dotted vertical lines. Cut out each spring along the solid lines. Fold each on the fold lines as indicated. Next, glue the ends of the flaps together with a dot of white glue. These hinges will be glued to the backs of the framed photographs in order to glue them to the disk. However, each hinge does not have to be centered. In many instances it will work best if placed off to the side or in a corner so that the photos fit well and all can be seen. Follow our layout as a guide.

Begin by mounting four of the larger photos onto the disk. With each additional picture you will glue the hinged picture in the position determined by your layout.

To finish off the wreath a bright red ribbon is glued to the back of the disk for hanging. You can add a large, full bow at the top as well.

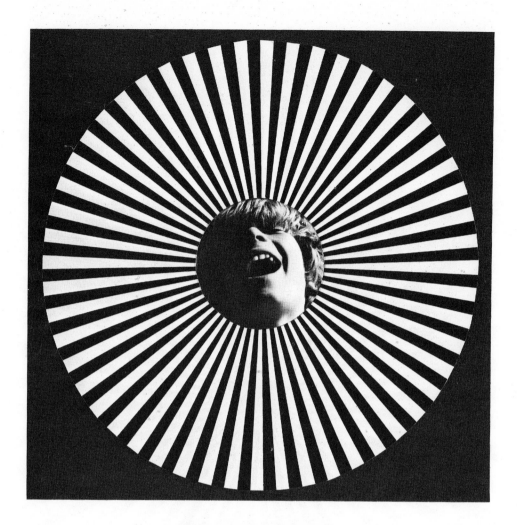

Op-Art Photo

Sometimes an ordinary picture can be improved by placing it on an unusual or arresting background. Wrapping paper, cards, or graphic designs can often dramatize part of a photograph. The fun is in making the picture and the background work together. You might look through books for patterns. The Dover paperback design-books are specifically designed so people can cut out the designs and use them. The books are relatively inexpensive and you will find hundreds of ideas in them. You can also make a photostat of a design from this book, or you can create your own background design with black-and-white or colored markers.

The photographs you select for this purpose do not have to be special, but very often will look special when teamed with the right background. The picture used here is quite small, but for a really dramatic effect use a larger photograph and create a smashing poster-size background. It could be a large target design with the person's head in place of the bull's-eye. Botanical posters are another suggestion, with a large flower framing a baby's or child's face.

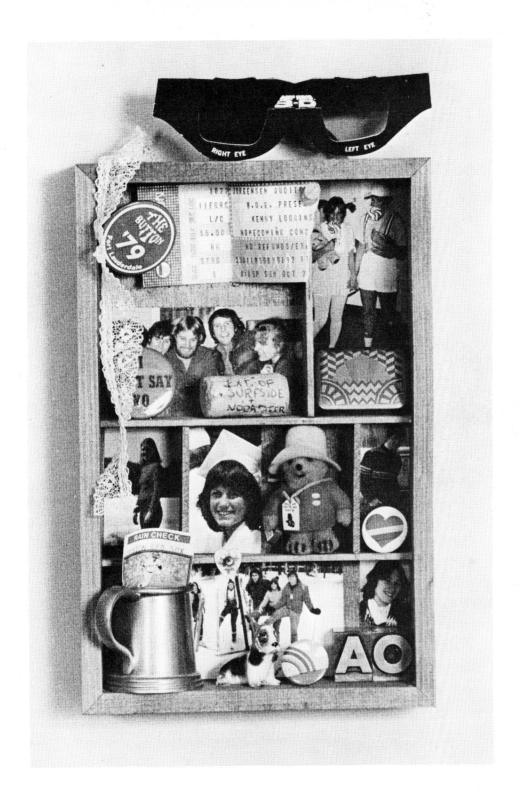

Nostalgia Assemblage

An assemblage is a collection of things designed together in such a way as to create a complete picture. The theme can be personal, artistic, or just fun. A nostalgia assemblage is a very personal expression of things that are significant to the person making it.

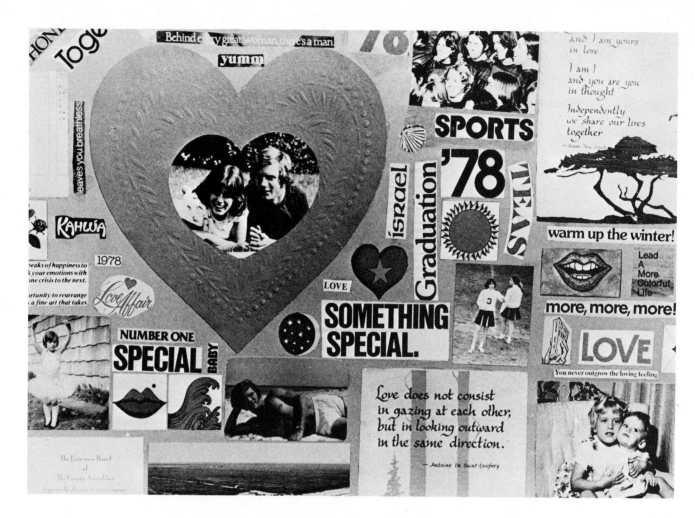

For this project you will need a type drawer, shadow box, cigar box, or any similar box or container. Cigar boxes are good to use if you can find them. Craft stores have shadow boxes like the one used for this project. The dividers are made from balsa wood strips used for model making. They can be cut with a craft knife and glued in position with white glue, such as Elmer's.

Begin by rummaging through drawers, old scrapbooks, yearbooks, albums, and so on, to pull out scraps of things you've saved over the years. Arranging the items can provide endless amounts of fun as you remember back to the time that you used or collected each item or enjoyed each event.

Determine the size of each compartment based on the pictures and materials you will use in your assemblage. Stain or paint the outside of the box as well as the balsa strips. Wood stain is available in a variety of simulated wood grain colors from the hardware or paint store. When dry, cut the balsa wood to fit your project and glue each strip in position.

The background for everything you assemble might be photos, tickets, a program, an article from the newspaper. Other sugges-

tions are miniature furniture, school letters, your initials in three-dimension. It depends on the type of assemblage you are creating. You might decide to do an assemblage of your ancestors. Use photographs combined with such things as old lace, a patch from a wedding dress—anything that symbolizes each person for you. Sections of a map, cutouts from magazines, wrapping paper, a pressed flower are some of the things to use.

Choose a theme for your collage and try to carry it out in every way. Create a mood by the selection of colors as well as by the items and their placement. Try to be consistent. For example, if this collage is about your trip to Florida use sunny colors such as orange, yellow, and white. The objects that you combine with the photos of your trip might be a coaster from the Shipwreck Bar, and a postcard saying "Welcome to Sunny Florida." Stick in an orange bubble-gum ball, glue in some sand and some shells collected on the beach. The items can even be glued to the outside of the box so that some hang out and over.

If the assemblage is a remembrance of your school years, make a corner of it bright and colorful using simple objects from grammar school. The high school section can be made up of your high school colors, a section of your report card (with the A on it), a picture of you at the senior prom, and the pressed corsage you wore.

Or you might try something a bit different, such as an autobiographical assemblage. It can really surprise you. Cut out things you like, things that you think represent you best, and add the pictures of yourself that you particularly like or that were taken at the most exciting times in your life. You can make it realistic or totally fanciful. Such an assemblage could also be a gift, representing all the fun times you've spent with someone special. The previous project is an assemblage because three-dimensional objects were used. If the material you've collected is flat, the result is referred to as a collage. The autobiographical collage shown here employs words and pictures to create a total expression. Many of the words are cut from magazines because they have personal meaning. A sturdy board, such as Foam Core, should be used for a collage background.

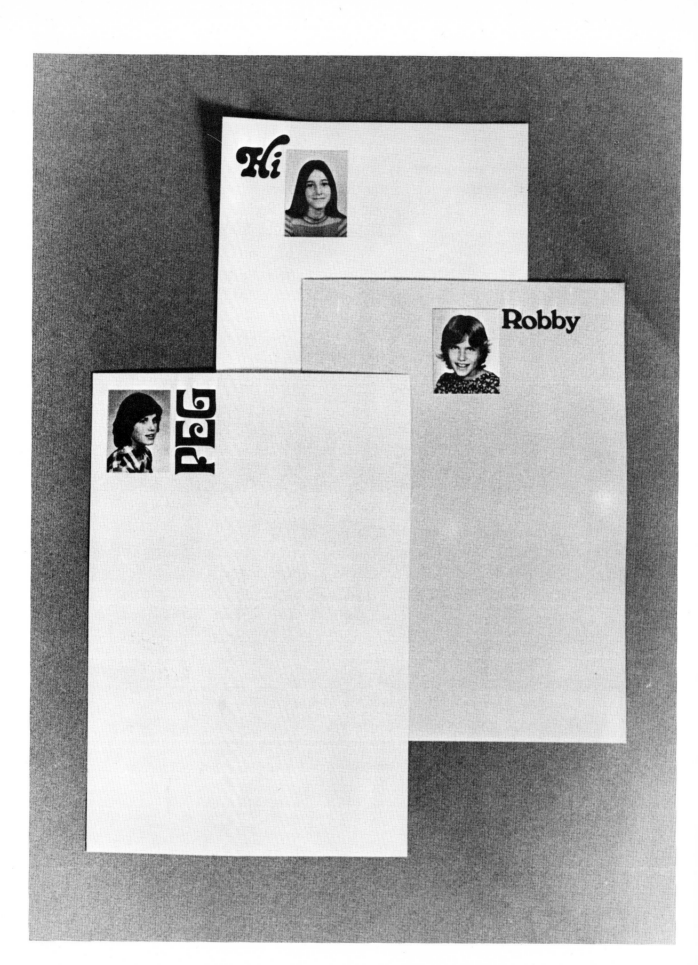

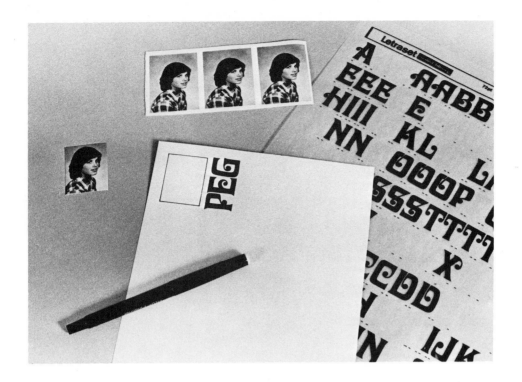

Personal Stationery

Personalize your letter paper not only with your name but with your photograph, too. First, make a number of duplicates of your favorite snapshot. This can be done very inexpensively. If you are a student, you could use your school photo, which usually comes with many copies.

In the corner of a sheet of paper, draw a rectangle in ink slightly smaller than the photograph you will be using. Then design and apply your name or initials or nickname with press-on letters to fit with your photograph. Press-on letters are found in art supply stores. There will be a selection of different sizes and typefaces to choose from. Take this sheet of paper to a printer. (Look in the Yellow Pages for a "speedy" or "quick copy" printing service). Two hundred sheets of stationery with your name and the box for the photograph on them can be printed very inexpensively. You will be able to select the paper and color from the printer's assortment, probably pastel yellow, blue, and pink, as well as white.

Once it's printed you can apply your photograph to the stationery to personalize your letter. Simply mount your photo with rubber cement over the printed square.

You can also design personalized stationery for a friend using his or her name and photograph.

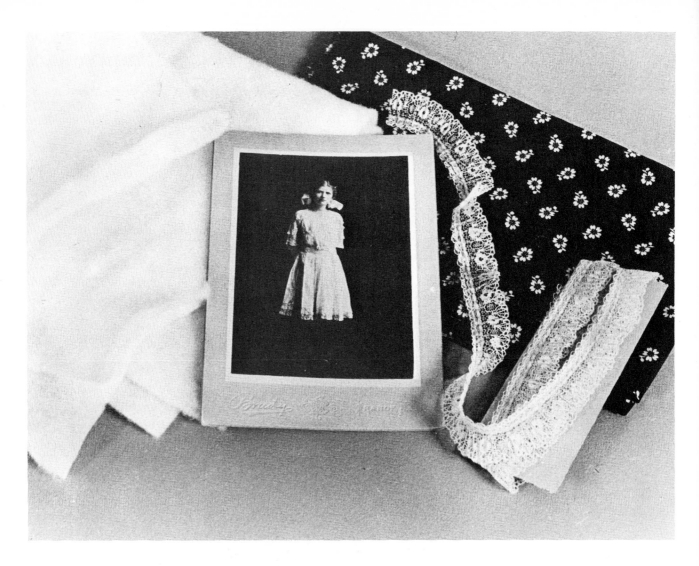

An Old Picture Updated

We all have old pictures of ourselves or relatives. It's fun to save a photograph of grandmother or mother as a little girl. Perhaps you have your parents' wedding picture. Such pictures don't have to look outdated and old. It depends on how we display them. A modern-looking padded frame can be made with any fabric you like. You can determine the effect by the fabric pattern you use. This picture, taken sixty years ago, suggests a delicate, overall small print fabric. A remnant is all that is needed, and the padding is cotton batting from a notions department. Both fabric and padding are attached to a cardboard background.

Corrugated cardboard is cut to the size you need for the photo you will be framing. Leave approximately a two-inch border all around, although it will look even better if the side borders are slightly narrower and the bottom about a quarter inch wider than the top.

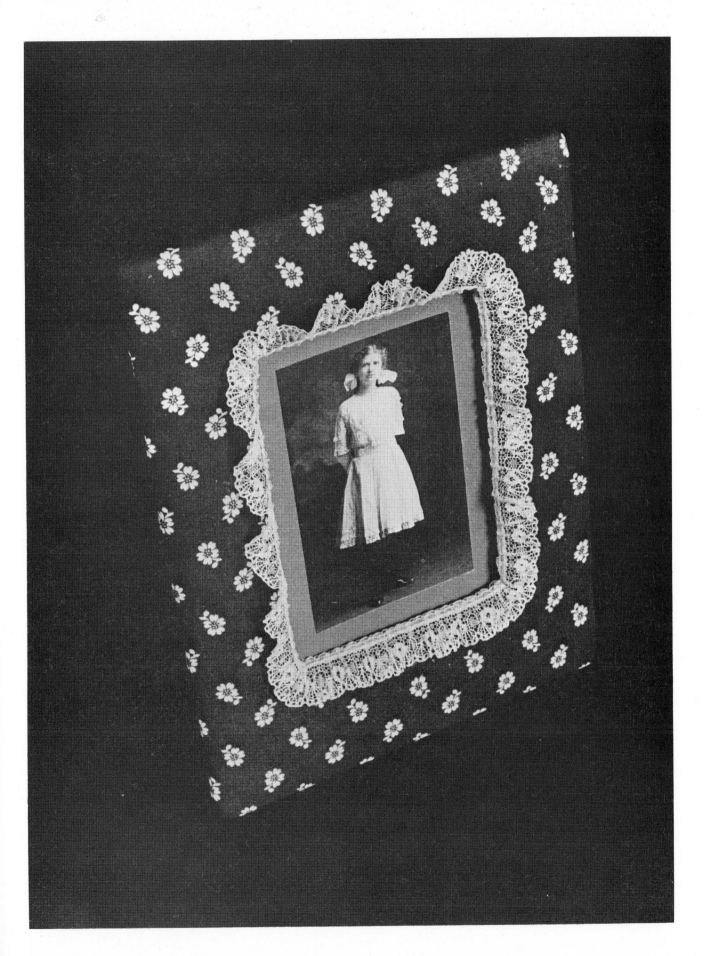

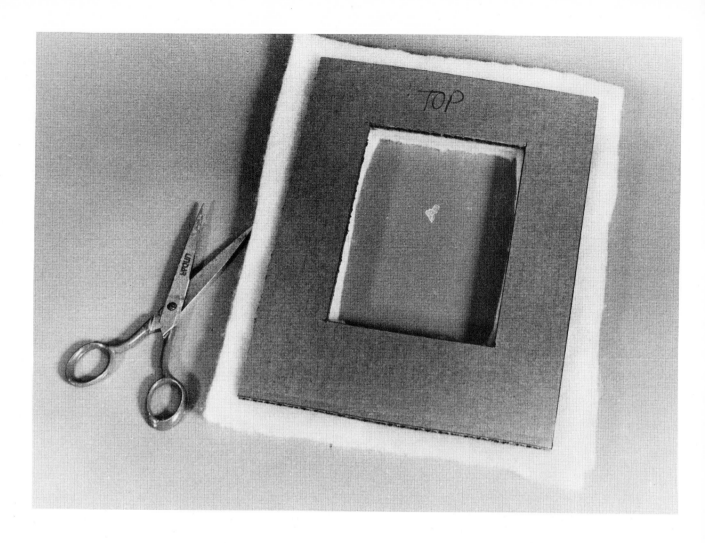

Lay the cardboard over a double layer of batting and cut it out. Cut away the center where the photo will show through. Cut the fabric an inch larger than the cardboard on all sides so you can fold it over the edges and tape this to the back. Make slits at the center opening from each corner, meeting at the center, and fold these toward the back. (See diagram.) Secure the fabric on the back of the cardboard with tape or glue. Pull the fabric taut as you do this. Since this is a graduation picture the young girl pictured here is wearing a lace-trimmed dress. Trimming the edges of the photo with lace seems to be appropriate and it will finish off the inside edges and soften the picture. Spread a thin line of glue along the edge of the lace trim and attach to the inside of the frame. Use one continuous piece, gathering it a little at each corner.

Trace the diagram for a stand. This can be used for any of the other projects in the book as well. Transfer the tracing to stiff cardboard and cut it out. Glue this to the back of the framed photograph for a free-standing picture. If you prefer you can hang with self-adhesive tabs.

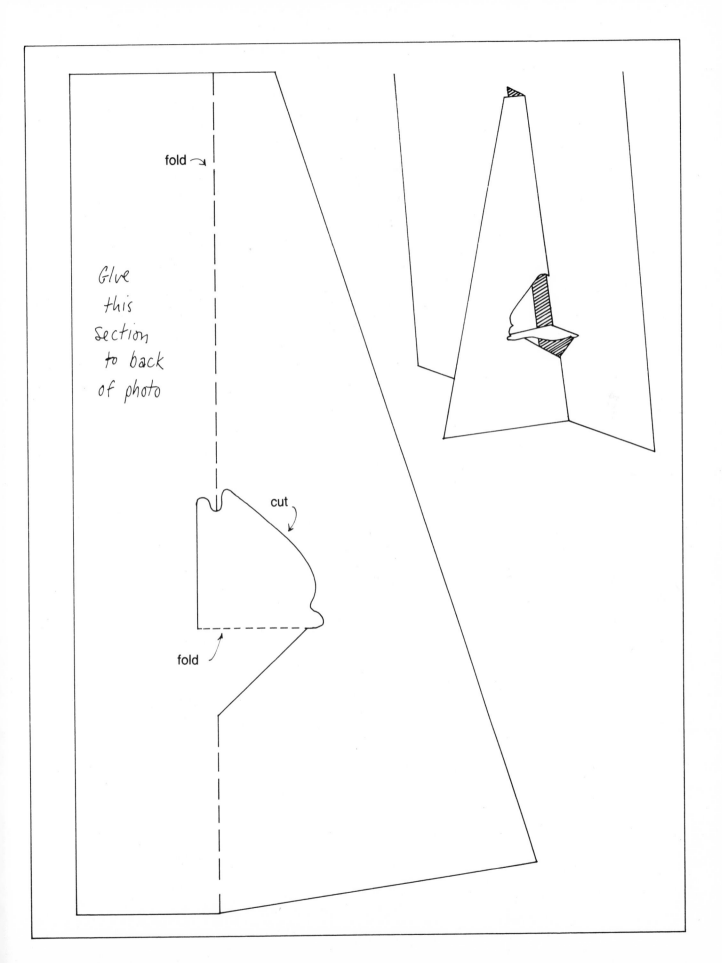

fold

Glue
this
section
to back
of photo

cut

fold

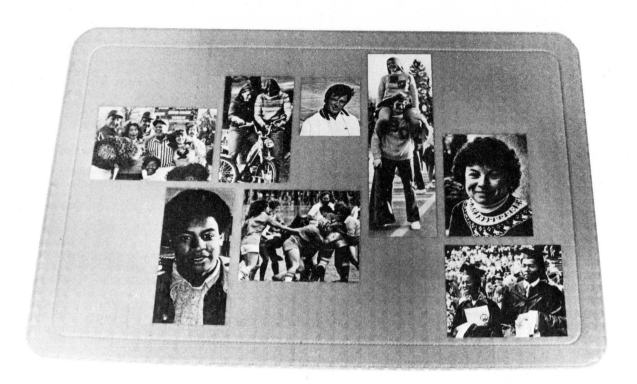

Photo Placemats

Photo placemats are a great idea for a family table setting, and a perfect gift for grandparents. You will need a selection of photographs, plastic placemats, Scotch brand mounting adhesive, and clear plastic Con-tact paper.

This project looks best when the snapshots are somewhat related. Assemble and trim a group of photographs so that you have a variety of shapes. Arrange them in a pleasing design on the mats. You might feel more confident if you do a tracing of the layout to remember the order of the photos. To mount the photographs, cut a piece of the Scotch mounting adhesive sheet to the same size (available in art and stationery stores). Peel away the backing and place the adhesive coated sheet against the back of the photo. Apply pressure to the sheet with a squeegee (which is included in the package) in order to transfer the adhesive to the back of the photo. Peel the photo away from the sheet and position it. If it isn't exactly right, pick it up and reposition before applying pressure for a permanent bond. For an added touch, cut a piece of cotton fabric in a pretty pattern to the exact measurement of the placemats. Apply rubber cement to the back of each mat as well as to the back of the fabric. Let dry. Mount the fabric to the backs of the placemats.

Finally, cut two pieces of clear Con-tact a bit larger than the mats. Put the mats between the sheets of Con-tact and seal together. This will both protect the photographs and the fabric from moisture.

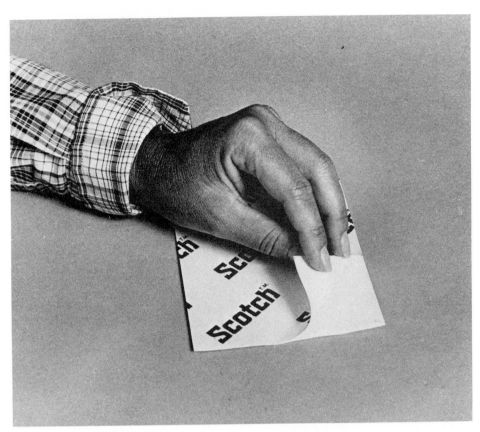

Peel backing from photo mount.

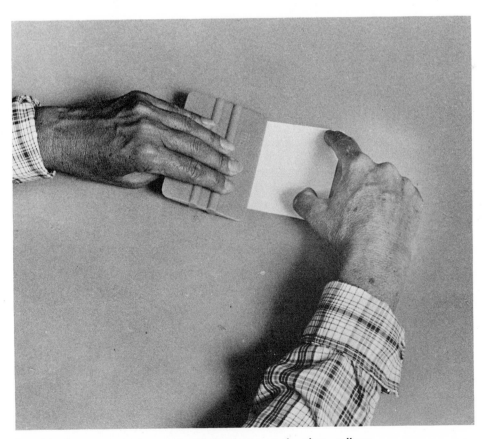

Burnish photo mount; remove backing paper to make photo adhere.

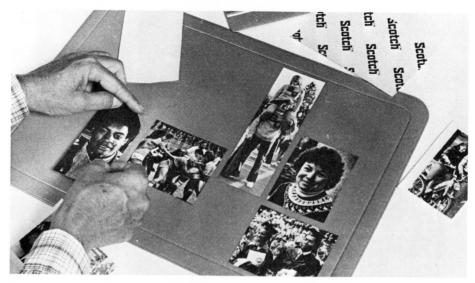

Place in position. Picture can be picked up and moved if necessary.

Apply Con-tact with care.

Trim with scissors.

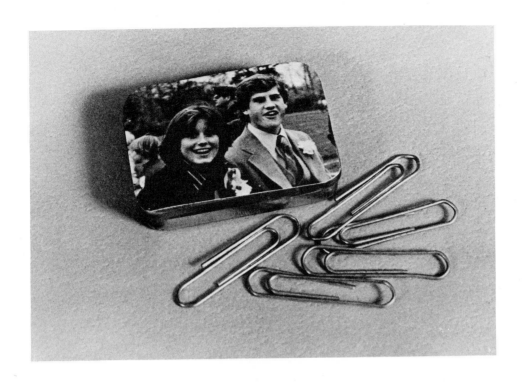

Desk Organizers

If you want to have an organized desktop and still have room to display your favorite photographs, this project that makes both possible should be just the thing. It takes little time and no money since everything used can be found around the house. Little things such as paper clips, rubber bands, thumbtacks, staples, and labels can be kept in jars, bottles, tins, or boxes you would normally throw away. By decorating the tops with photographs, you can make even an unsightly aspirin tin look interesting. And every time you need a paper clip or fill a stapel gun you are reminded of people you know. This is also a good way to use the leftover pictures that weren't quite good enough for the album or frame. Often we take a snapshot of several people and someone is half out of the picture or is caught in an unflattering pose. This is the time to cut off the bad portion, using only the tiny section of the photo that you like.

It doesn't matter what type of container you put the pictures on. Many different sizes seem to look best in a group. We used an aspirin tin, a plastic button box and another small plastic box, a small cardboard box that once held a piece of jewelry, a film can, a round cardboard box that once held candy, another candy tin, and a little matchbox. Other suggestions are adhesive bandage tins, cans, jars, spice tins, or any similar commercial packages. Before tossing anything of this sort into the garbage can, think about its possibilities for this project.

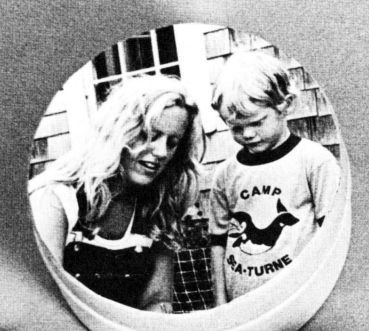

16mm film can

aspirin tin

35mm film holder

plastic container

bug box

cardboard box

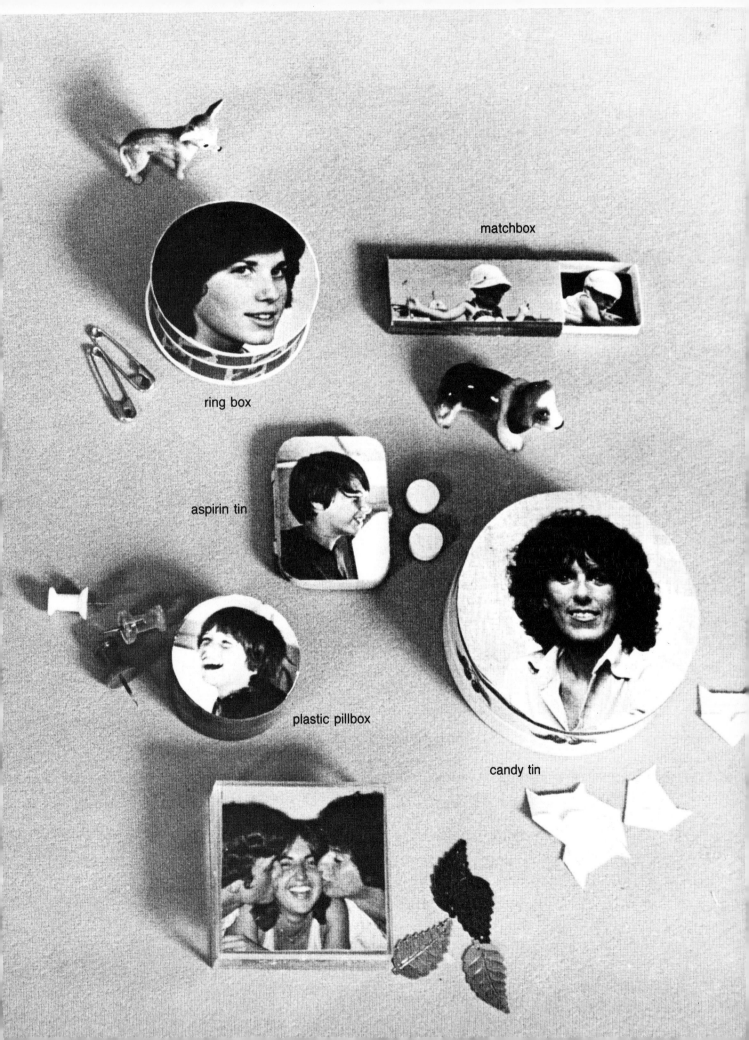

matchbox

ring box

aspirin tin

plastic pillbox

candy tin

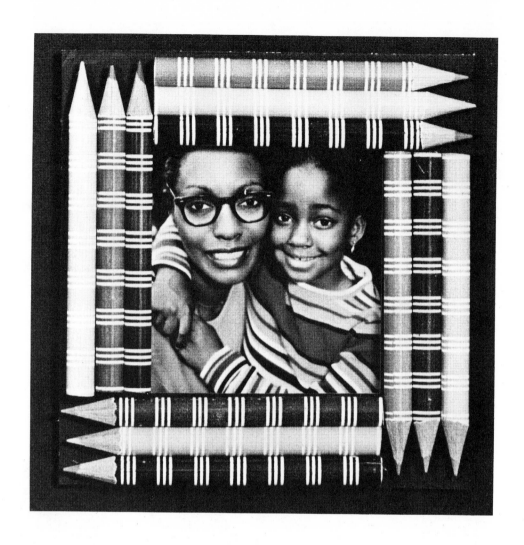

Pencil Portrait

When I spotted brightly colored striped pencils in the dime store, I was inspired to use them to frame this photograph of a girl in a striped shirt. One box of pencils is enough for a 3-by-3 inch photograph.

Using a utility saw, cut the pencils in half. Put a piece of sandpaper on the tabletop and rub the rough ends of the pencils over it until they are smooth.

In order to make the photograph fit the frame, begin by laying the pencils around the picture until you get the right effect. Arrange the colors any way they look best with your photo. To keep them from rolling around while you're figuring out the arrangement, tape each set of three together temporarily.

Once you have the arrangement planned, cut a black mat to fit the exact size you want. In this case the center square is cut smaller than the 3 1/8-by-3 1/8 inch picture.

The striped pencils and a striped shirt combine to spark an idea.

Check to make sure everything fits before gluing down.

Lay all the pencils around the mat background. Since every pencil has printing on it, to avoid having it show squirt a thin strip of white craft glue along this line of type. Set each pencil in place one at a time. Each pencil needs only a little glue to hold it and each must be placed tightly against the next. Set the frame aside to dry before placing the photo in position. Tape the picture to the back of the frame with masking tape and it is now ready for hanging.

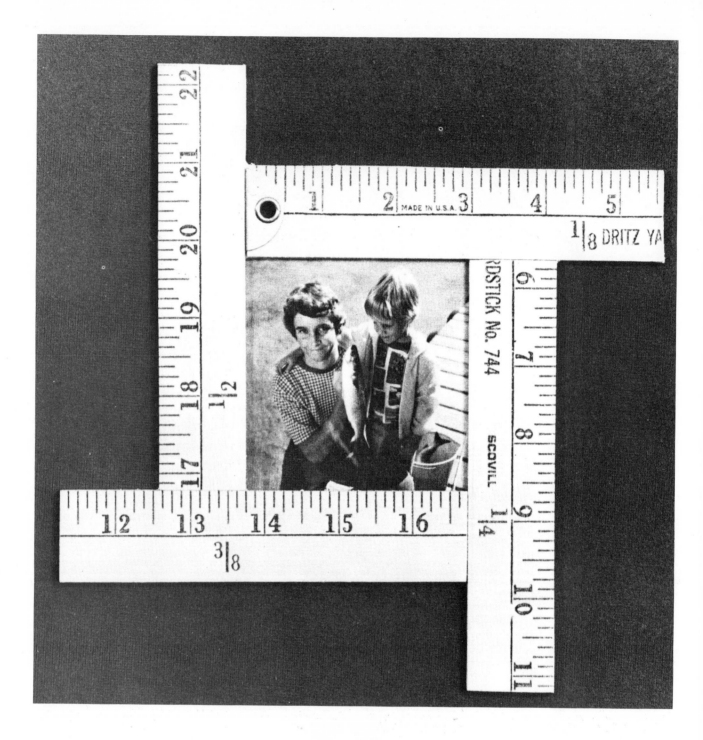

So Big!

This is a good way to frame the picture of the fish that didn't get away. A wooden yardstick is soft enough to cut with an inexpensive utility knife or saw. It is easy to make this frame to the exact size you want since you have the measurements right in front of you. If you use a square photo for this project, you'll find that a yardstick is easy to square up. Leave plenty of room around the picture for the frame. You'll not cut the outside dimensions until the end.

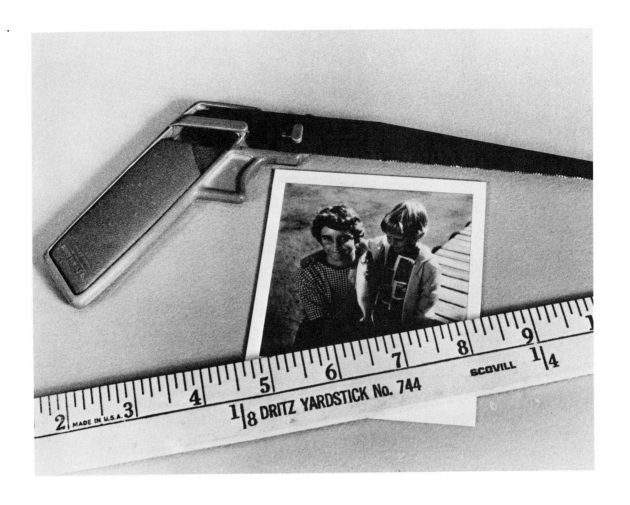

Yardsticks are available in hardware and paint stores for about seventy-five cents. They come in natural wood and can be used as is or can be given a coat of stain in the color of your choice. Yardsticks also come in bright colors such as red and blue, but if you want an unusual color, use a spray paint. The numbers will show through a coat or two of paint.

Cut four pieces of yardstick, each measuring 5 3/4 inches for a 3-by-3 inch picture. Sand the edges so they aren't rough to the touch. Glue the pieces in position on the cardboard around the square that you have cut out. When the glue dries, trim the excess background cardboard with a sharp craft knife.

If you want to crop the photo in a diamond shape, you can use the hole in the end of the yardstick for easy hanging.

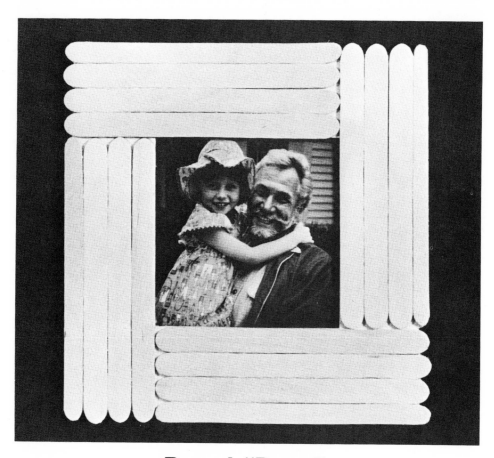

Proud "Pops"

You don't have to eat ice cream on a stick all summer to save enough material to make this wooden frame. Now you can buy a package of popsicle sticks in the five-and-dime for about a dollar.

Determine how deep a border you will want for your picture. This is a 3-by-3 inch Polaroid color print and the border is four popsicle sticks wide on each side.

It is easiest to apply the sticks before cutting the cardboard around the outer edges. Begin by cutting out a three-inch square where the photo will go in a piece of heavy cardboard. Apply white glue to as much of the surrounding area as you will need for the frame and line the sticks around the edge of the cut-out square. When you have all the sticks glued in place, draw a line around the outside and cut with a sharp razor blade or craft knife. You'll then have to trim away the cardboard where the sticks curve at the ends. This is best done with a sharp craft knife such as an X-Acto.

You can leave the sticks in their natural state; or if you wish to make them darker, stain them with an oil stain such as Minwax, available in hardware stores. A dark walnut would be quite handsome. For added finish, apply a coat of varnish, which will make these sticks look like rich wood.

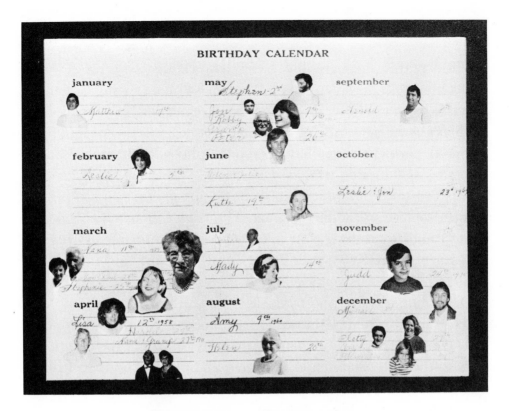

Birthday Calendar

Create a birthday calendar to hang on the wall so whenever a birthday or other special occasion comes along you won't forget it. Make the calendar using markers. This calendar is 12 by 14 inches.

Gather together some family photographs past and present. You may have to try several before finding just the right sizes to fit on the calendar, especially if there is more than one person for each month. Cut out and paste head shots under the month of each person's birthday, anniversary, or whatever. Write the name and the date alongside. Be sure to arrange all the photographs before starting to glue so you can rearrange to fit in the most pleasing way.

Dry mount the calendar sheet on posterboard with rubber cement.

The calendar can then be enclosed in an inexpensive thin frame which can be painted any color you choose. If you want to go further with the project you might cut out pictures of flowers of the birthday months to paste alongside each one. This is a good Christmas idea and also an excellent way to put those not-so-terrific family photos to good use. Since the main idea here is to remember the birthday, and since each person's name is written on the calendar, the picture is not so crucial. It is simply an attractive addition. So if someone's picture is a little out of focus and not good enough to save, cut out the head and use it in this way.

Friends Frame

The way this photograph of two friends is matted is an example of the hundreds of ways to take advantage of photostating. Anything that is printed can be made to the exact size needed for your project. In this case the definition of the word "friend" was taken right from the dictionary. You may have a similar photograph which can be treated just the same way.

A photostat is different from a photocopy in that you can reduce or increase the size of the original. The copy will also be black and white rather than gray as in a Xerox copy. Photostat services are listed in the Yellow Pages of your local directory and many copy centers provide this service.

Determine the size photostat that you will need. For example, if you use an 8-by-10 inch frame, you will need an 8-by-10 inch photostat. Photostats cost more as they increase in size. Take the dictionary to the photostat center and give them instructions to make a negative photostat of the section you want. This will cost approximately three dollars.

The photograph you use for this project should be fairly small in order to dramatize the effect and to have a contrast between the background and the photo. In this case the background of the picture was cut away and a third person who was in the picture was cropped off. If the photograph that you choose has a white border around it, this should be trimmed away. Use a metal rule and sharp razor blade to do it exactly. When planning this project, keep in mind that frames come in standard sizes, so don't use an odd dimension.

For variations on this idea consider photostating part of a poster or the front page of the newspaper on the day of a baby's birth. A menu from an elegant restaurant you visited can be photostated down to a size that will fit a standard frame. Onto this background you could put a picture of yourselves taken at the time. A picture at a prom might be used against a background of an enlarged photostat of the invitation or a graduation picture against the program made to whatever size you want. You could have that section with the name you want blown up to fill the entire area within the frame.

friend (frĕnd) *n.* **1.** A person whom one knows, likes, and trusts. **2.** Any associate or acquaintance. Often used as a form of address. **3.** A favored companion; boy friend or girl friend. **4.** One with whom one is allied in a struggle or cause; a comrade. **5.** One who supports, sympathizes with, or patronizes a group, cause, or movement. **6.** *Capital* **F.** A member of the Society of Friends; a Quaker. —**be friends with.** To be a friend of. —**make friends with.** To enter into friendship with. —*tr.v.* **friended, friending, friends.** *Archaic.* To befriend. [Middle English *frend*, Old English *frēond.* See *pri-* in Appendix.*]

friend·less (frĕnd'lĭs) *adj.* Wi

friend·ly (frĕnd'lē) *adj.* **-lier,** ng to, or befitting a friend. **2.** Favora agonistic. **3.** Warm; comforting. **4.** On *adv.* Also **friend·li·ly** (frĕnd'lə-lē). In th amicably. —*n., pl.* **friendlies.** One fighti ne's own side. —**friend'li·ness** *n.*

Friendly Islands. See **Tonga.**

friend·ship (frĕnd'shĭp') *n.* **1.** The condition or relation of being friends. **2.** Friendly feeling toward another; friendliness.

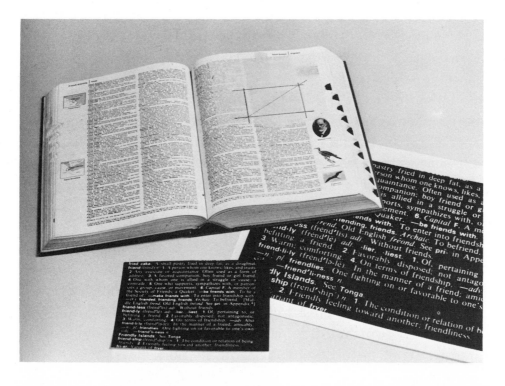

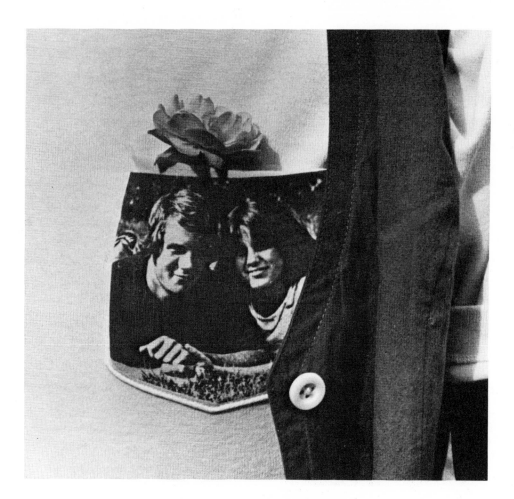

Picture Pocket

You can have any picture made into a transfer to apply onto fabric. To do this project you will need access to a copy center that has a color Xerox machine. Most copy or photostat concerns have them. This is how it works: The picture fits into the color Xerox machine, which reproduces it on a wax backing. The process costs about two dollars per transfer. However, you can fit four 3-by-5 prints on one page for the same price. This is a good way to personalize T-shirts for the whole gang. Use a group photograph and make a T-shirt for each person in the picture.

To transfer the picture to the pocket of the shirt, slide the shirt onto the end of an ironing board. Set your iron for cotton. Lay the transfer facedown over the pocket area. Place a piece of silver foil over the back of the transfer. This will prevent the paper from scorching. Applying pressure and heat to the back of the transfer will fuse it to the material. Move the iron back and forth over the entire area, applying pressure as you do so. Remove the iron, wait a second or two, and then peel the paper backing away from the transfer. Your picture will appear on the pocket.

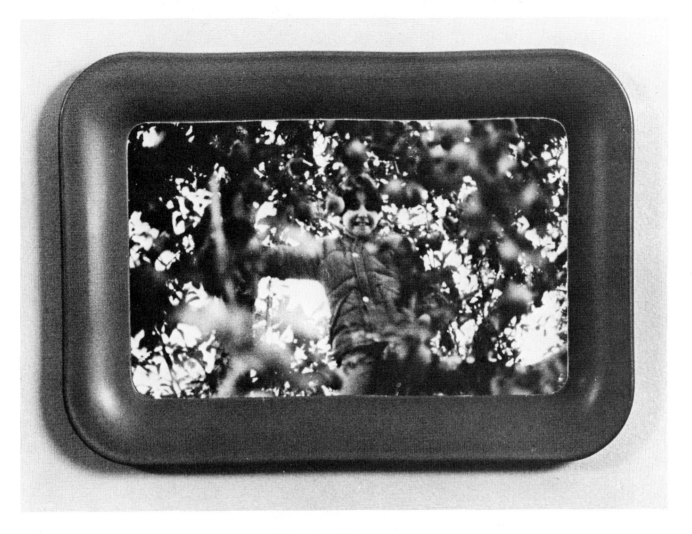

Tray Frame

Small 5-by-7 inch metal trays in a variety of colors can be found in the dime store for under a dollar and make good frames. First, select the right size, then look for the right color. These trays take spray paint very well and if you can't find a specific color, you can always repaint, although this adds to the cost. In a project like this, where very little has to be done, pay attention to details. Make sure that the snapshot you choose fits exactly right. Trim the edges and shape it to fit. For instance, in this case the corners of the tray are rounded. The corners of the picture must therefore be curved to fit. This is best done with cuticle scissors. Match the colors in the photograph with the color of the tray. As the girl's jacket and the apples are red, a red tray was selected which is offset by the profusion of greenery in the picture. Glue the photo in place and hang with self-adhesive tabs attached to the back. This tray suits a vertical or horizontal picture. Several can be grouped in different colors for a variety of subjects.

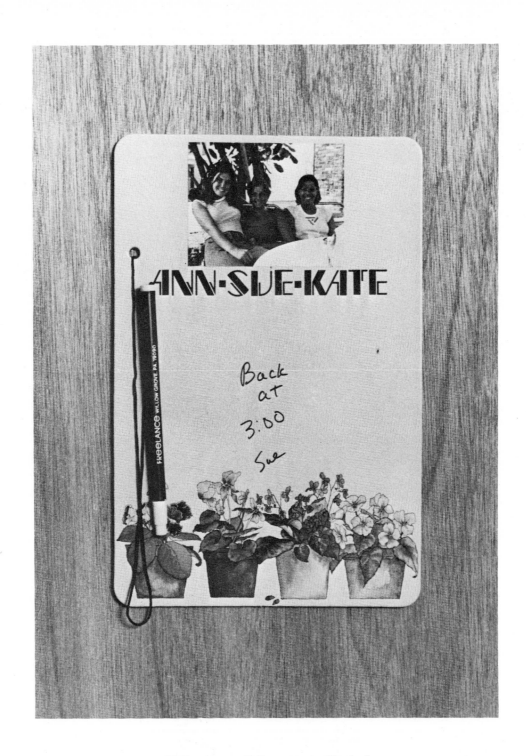

Photo Memo Pad

If friends are always stopping by when you aren't home, a handy memo pad might be the answer. College students often place a wipe-off memo pad on their doors in the dorm, so this might be a good gift for a college-bound person. In this case a photo of three roommates is mounted on the pad.

Plastic memo pads are available in stationery and novelty stores and generally come in two sizes. The writing marker is attached.

Select a photo that will fit well on the top of the pad and simply glue it in place.

Next, add each person's name, or initials if there isn't room for all the names. Of course, if the pad is only for one person, it is easy to fit the name below. The names are made from transfer or press-on letters that are available in art supply stores. Sheets of the letters come in many different typefaces and sizes. Choose something to fit the area where it will be used. It takes minutes to apply the letters. Use a pencil to make a guideline on the pad. Place the type sheet on the pad and, using a butter knife, closed pen, or similar utensil, rub the back of the letter in order to transfer it to the pad. Continue to do this taking care to make the letter spacing equal. And the project is finished. This could also be a terrific shower present for a bride-to-be. Use a picture of the couple or take a Polaroid picture at the shower and have the memo pad with you, with the couple's name already in place. Then just mount the photo on the pad right then and there. Since you already know the size of your Polaroid pictures, it will be easy for you to plan where the photo will be placed in order to apply the name in the correct spot.

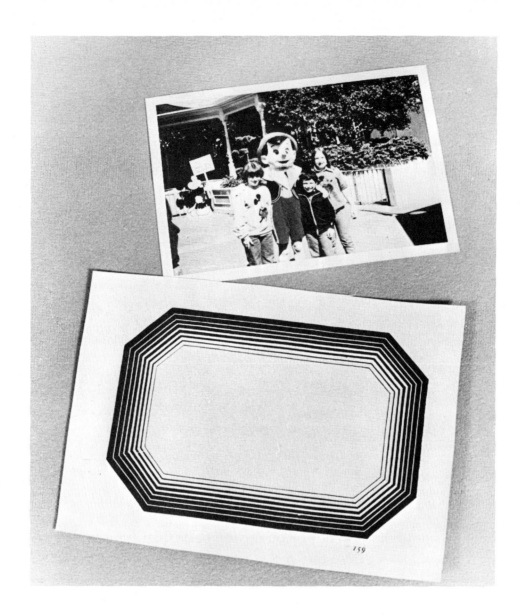

Our Trip

Make a souvenir album for photographs of your trip or vacation. The one shown is done in a traditional way—using black pages and photo corners to hold the photographs in place so it looks like a scrapbook. You can even add mementos saved from the trip such as programs, ticket stubs, postcards, and so on.

Select a picture that best depicts the whole trip to place on the cover. In this case the cover shot symbolized the trip to Disney World better than any other picture that was taken.

All the pictures used for this album are square color prints and two fit nicely on a page which is 10 by 5 inches with an extra half inch for the side fold. Black cover stock, available at camera or art supply stores, is used for both the pages and the front and back covers. It is heavier than construction paper, but not as stiff as

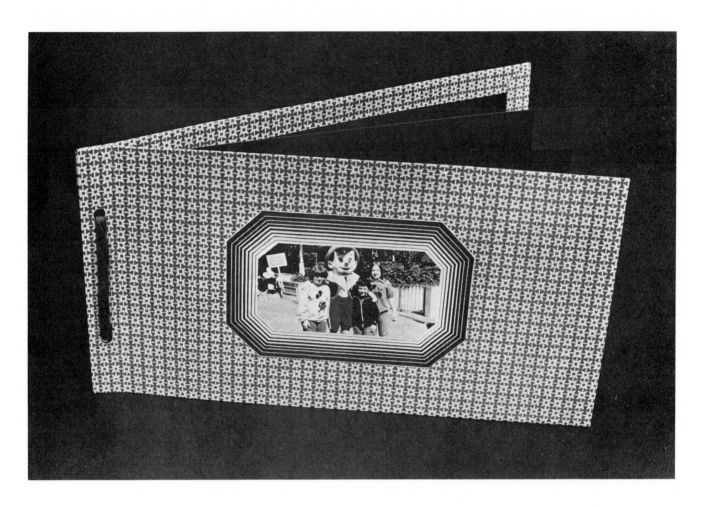

posterboard. The common black corners are also available in white at camera or dime stores. These covers measure 5 3/4 by 11 inches but your album can be any size that will hold your particular photos best.

Select a wallpaper or wrapping paper with an overall small print that will look well with your photos. Cut two pieces of paper at least a half inch larger on all sides than the covers. Coat the back of the paper and the front of the covers with rubber cement. When dry, mount the paper to the covers leaving a half-inch border which will be folded and pasted to the inside. The corners must be tapered so they can be folded neatly. Coat the inside of both covers with rubber cement and let dry. Cut two more pieces of the decorative paper to fit the inside of the covers and coat them with rubber cement. When dry, mount to the covers. This finishes them off nicely.

Next, cut the inside pages. You can have as many as you want, depending on the number of photographs to be used.

Take the photograph that you have chosen for the cover and design a label for use as a border around the photo. To make the label you can use the art provided here or create your own. You can

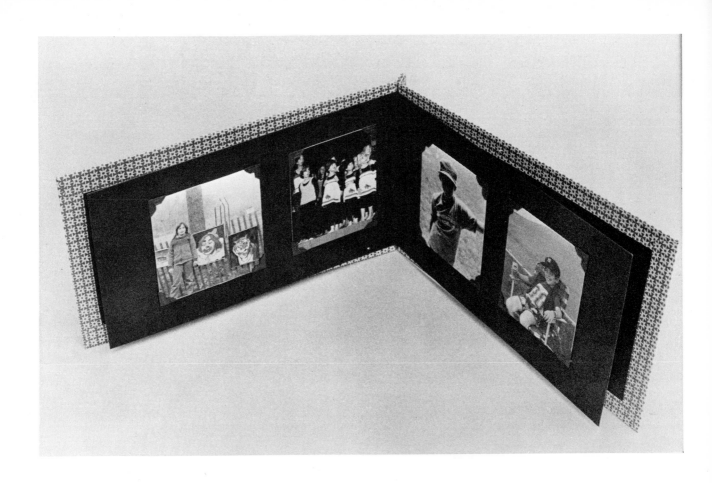

have a photostat made from the label provided here. The photograph can then be mounted inside the label. To make sure that it will fit correctly, lay a piece of tracing paper over the border and trace the inside lines. Tape this tracing over your photograph and cut to fit, using a straightedge and a sharp razor blade or craft knife. Coat the back of the picture and the front of the label with rubber cement and let dry. Place the photo in position on your label and press down. Position the label as desired and glue or dry-mount to the album cover.

Now you have all the pieces. The pages for the inside are cut to size, the cover pieces are finished, and the photo label is on the front cover. Next, you must score the cover and pages one-half inch from the left-hand edge so when the album is bound, it will open correctly. This must be done accurately or the pages will be crooked.

Lay the straightedge along the line to be scored. The ideal tool to use is a ball-point pen that doesn't work or something with a dull point that will make an indentation without cutting through the paper. Run this along the straightedge on each page and both end covers. Put all the pages between the covers and with a pencil make

a mark on each page where holes will be punched. With a paper punch, make each hole in position.

Tying a ribbon or yarn through the holes completes this project. Once you have placed all the pictures in the album you can write names and dates with white ink which is available in art supply stores. Or you might prefer making stick-on labels for each photo.

Each of these mini mats is the center of one of the novelty mats that follow.

Novelty Matting Projects

Here are some suggestions for unusual ways in which you can mat or frame a particular photo. I'm sure you'll come up with many other ideas once you begin to think about it. The matting need not be plain-colored paper or posterboard. Try a fabric that contrasts with or offsets what the person in the photo is wearing. Worn-out jeans can be cut up and used as a background for a photo of a jean-clad teenager. A dish towel, believe it or not, can be just the thing for a photo you want to hang in the kitchen. Frame a child's picture with a jump rope, or a coin collector's picture with coins, or a gum chewer's picture with balls of bubble gum.

The following pictures are examples of what can be done with photographs you may already have. If you do not have such photos, you may be inspired to set up a shot in order to try out some of the ideas suggested below. The only tool you'll need will be a very sharp, single-edge razor blade or a very sharp craft knife.

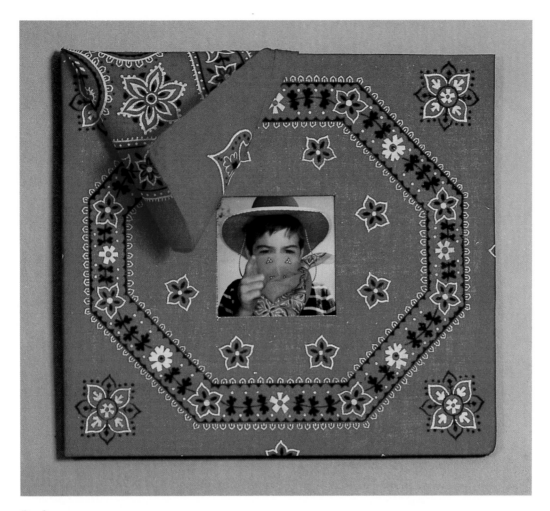

Cowboy

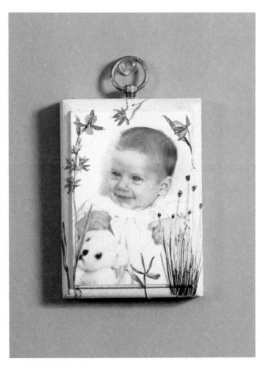

Baby Plaque

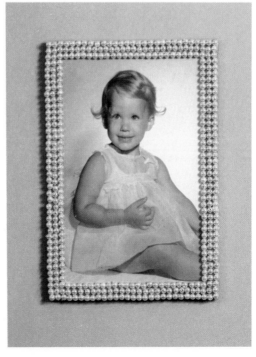

Beaded Border

Address Plaque

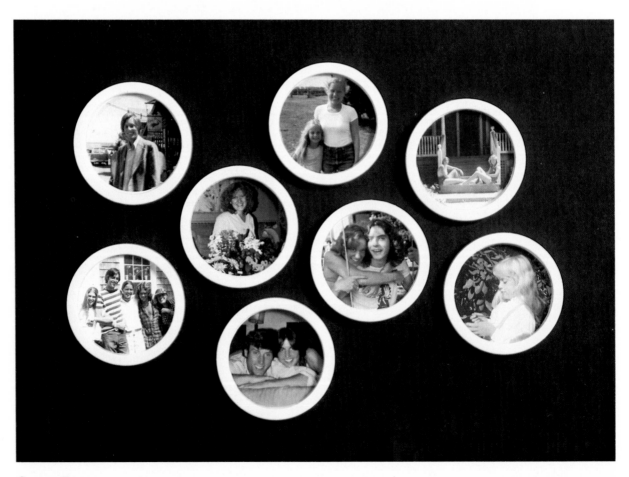

Coaster Frames

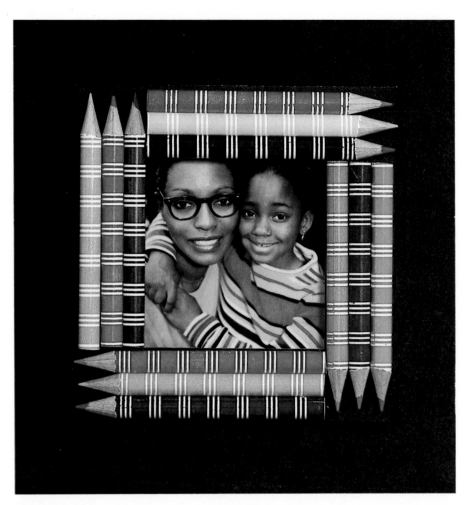

Pencil Portrait

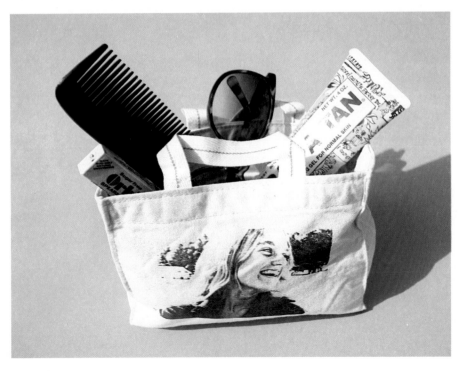

Bagged

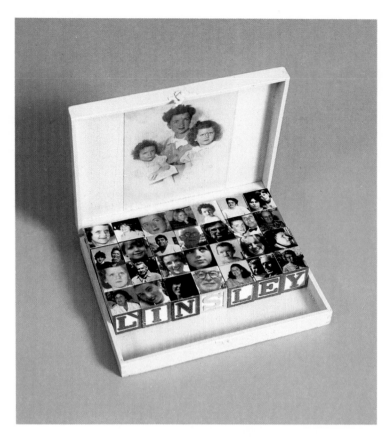

Block Party

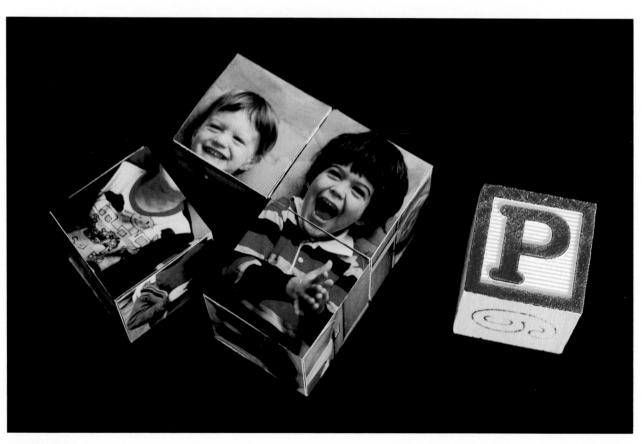

Photo Cubes

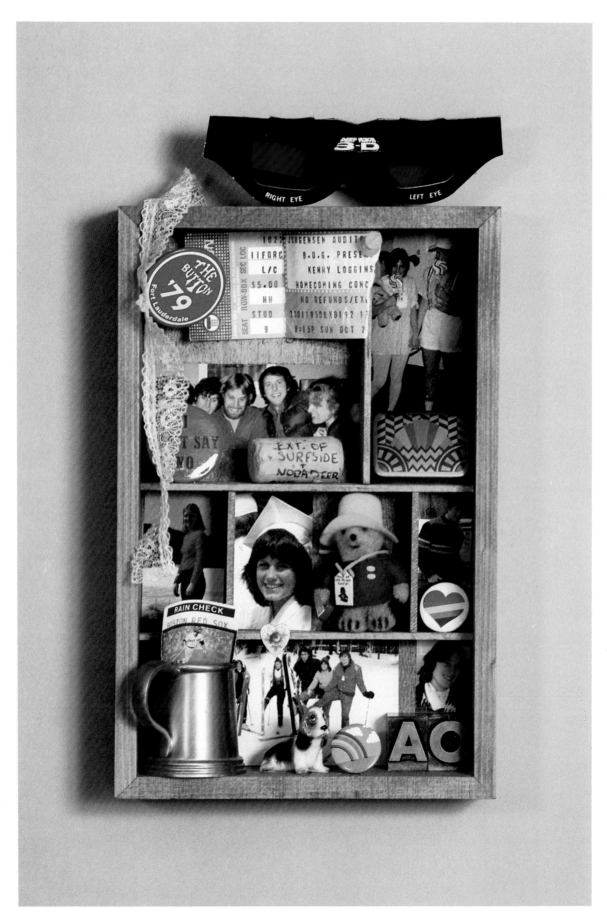

Nostalgia Assemblage

Nature Study File

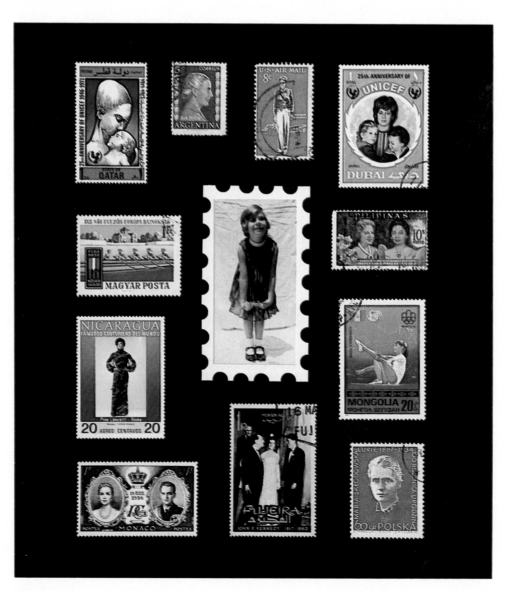

Stamp Act

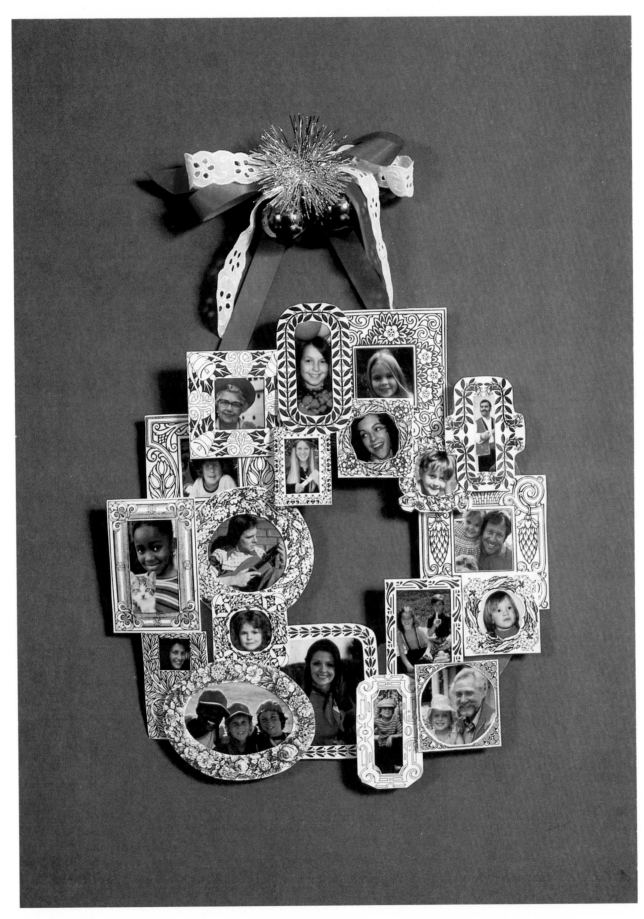

Photo Wreath

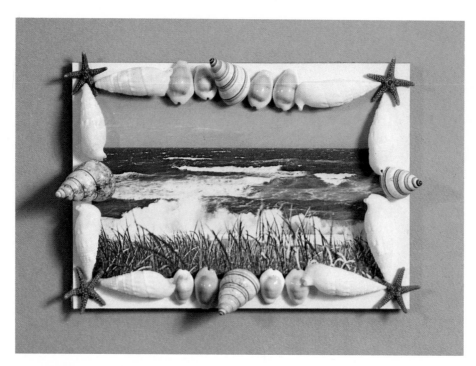

Seashells by the Seashore

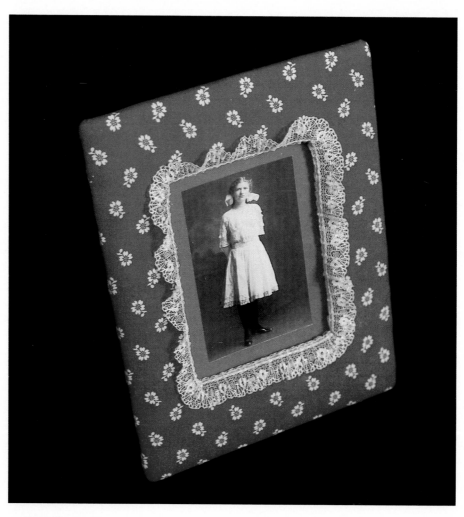

An Old Picture Updated

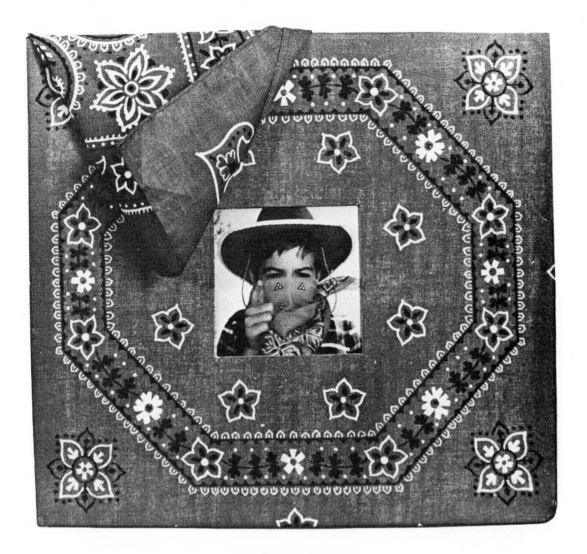

A Cowboy

This Polaroid picture of a young cowboy is made much more effective by the addition of a bandana frame. The neckerchief was purchased in an Army/Navy store and cost sixty-nine cents. Determine the size of the frame you want by making a tracing of different sizes and placing it over the photo to see what looks best.

Cut the cardboard to the size you've chosen and then cut a square in the center where the photo will go. Coat the cardboard with rubber cement and let dry. Next, place the bandana over the entire piece of cardboard, covering the hole as well. Smooth it down so that it is completely mounted. With a sharp razor blade, cut away the center area.

Turn the frame over and tape the photograph in position. The extra material can be cut away or taped to the back but leave a little bit at the corner to pull forward. This gives the frame a jaunty, casual look and adds a three-dimensional quality as well. You can then put the whole thing into a thin black frame or hang it as is.

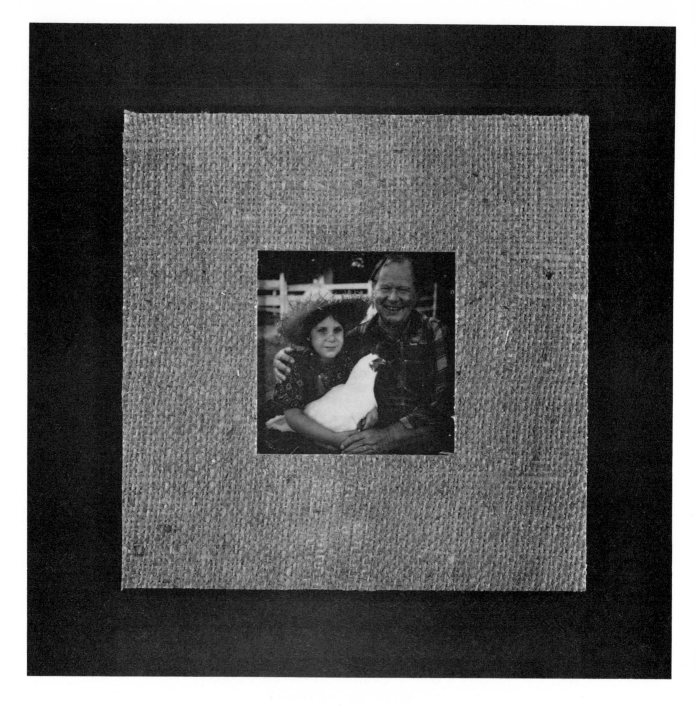

Farm Scene

A photograph of your visit to a farm would go naturally with a background of burlap. Cut the cardboard backing to the size you want and mount the burlap to it with rubber cement. Remember to use a very sharp razor blade to cut away the excess material around the mat and around the center square where the photo will go. If you want a frame, as well, you might consider covering it also with burlap. This will give the picture a bit of depth without detracting from the overall effect.

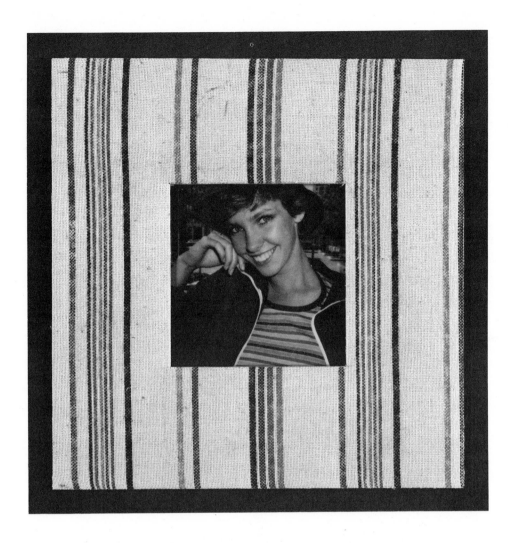

Dish-Towel Frame

A picture of a woman wearing a striped shirt suggests a corresponding mat idea. Here we've used regular dish-towel material. Look through fabric shops for other materials that would go well with your particular pictures. For instance, for a snapshot of the kids at Disneyland, you could use a background of fabric depicting Walt Disney characters. A photo of a child licking an ice cream cone could be surrounded by ice-cream-colored striped material. Or, for a picture of a dance recital, pink satin and lace to reflect the costumes. Frame a parade photo with red, white, and blue ribbons. For a wedding, you might use an overall piece of lace or, if you can't find lace, a large doily. For added effect, attach to one corner some dried flowers tied with a delicate ribbon. Surround a picture of your favorite chef with small kitchen implements. Simply empty out your kitchen drawers and see what you can find to use. Spray-paint all the items silver, white, or black. A picture of children playing jacks could be framed with rows of jacks and a red ball in one corner.

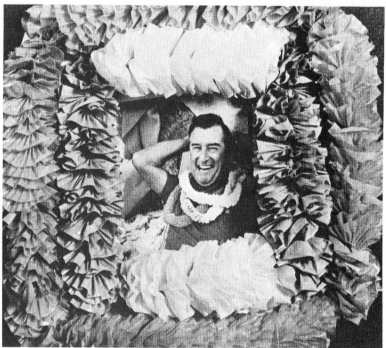

Harry In Hawaii

Uncle Harry went to Hawaii and took lots of pictures. This one taken of him is an example of how a photo might suggest an appropriate frame. Not intended to last forever, or to be taken too seriously, the idea takes minutes to execute for a fun gift. Dry-mount the photograph on a cardboard background that is two inches larger than the photograph on all sides. Using a sharp instrument, poke a hole in each corner of the cardboard. Carefully cut the lei so that each strip measures two inches longer than each side of the photograph. Apply a strip of white glue along the edges of the photograph and spread it to the outer edges of the cardboard. Place the strips of the lei onto the glue and push the ends through the punched holes. Glue the ends in place at the back of the cardboard. This will prevent the lei from unraveling.

Gingerbread Trim

Rickrack trim comes in many different sizes and colors. It is inexpensive and readily found in notions stores. You can use it to frame an appropriate picture such as we've done here. Use a single row or several depending on the size of your photograph.

Mount your photograph on heavy cardboard leaving enough of a border to add the rickrack. Spread a thin layer of white glue on the area to be covered including the edges of the photograph. When dry enclose in a dime-store frame that can be painted with matching or corresponding color.

Love Is All Around Us

Wrapping paper is beautifully designed and the variety is tremendous. Sometimes I am tempted to buy it even when I don't have anything I want to wrap. It offers many possibilities for matting a photograph.

This heart paper is a good example of a graphic design that works well as a background. The hearts are spaced so that the center square can be cut out for the photo without having to cut into any of the hearts.

Cut a piece of cardboard to the size you will need and coat it with rubber cement. Put this aside to dry. Next, cut the paper slightly larger than the cardboard all around. Coat the paper with rubber cement, and let dry. Dry-mount the paper to the cardboard. Then using a straightedge and razor blade, cut away the paper from the center section. Place the picture behind the mat and tape on all four sides with masking tape.

Graph-Paper Matting

The best part about this project is that no measuring is involved. You have the exact lines of the graph paper to follow for cutting. This paper is available in stationery and art supply stores. The paper is blue and white and is as neat and trim and starched looking as the nurse pictured here.

Using a piece of stiff cardboard, dry-mount the paper using rubber cement. Make a tracing to lay over the photograph in order to determine where you will crop it for framing. Use this measurement to cut the square in the center of the board for placement of the picture. Using the lines on the graph paper, cut the inside square from the mounted graph paper. To do this neatly use a metal straightedge and sharp razor blade. Determine how much of a border you want around the photograph and cut this out in the same way. You can now make a cardboard stand for the back or frame.

Travel Mural

Next time you take a vacation, buy a map of the places you went. When you get home and your pictures come back, you can combine the two for a memorable keepsake.

Crop your photographs so that they will fit on various sections of the map. It's fun to recall and try to pinpoint various places you visited. Remember the old mill? And the beach where the kids collected shells? And even Main Street?

Use rubber cement to mount the photos in position. You may have to adjust and rearrange to get everything to fit, but this is a project the whole family will want to help you with. Once all the photos are in place, select a frame that will look good. If the map is an odd size, you can mat it with a colored board to make it fit a standard frame.

Vacation photos are the raw material for this project.

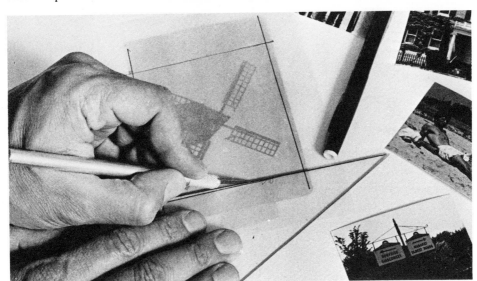

Crop away unnecessary details of photos.

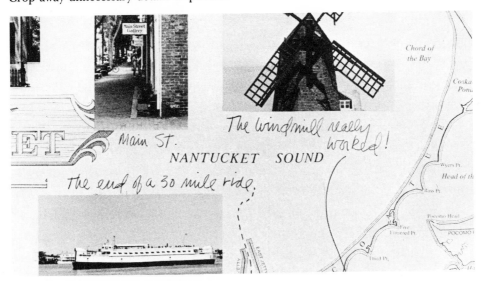

Personalize your mural with captions.

3-by-5 inch photo and blowup

Photo Blowup

Perhaps you've seen ads in magazines for blowups of photographs to poster size. For under five dollars you can send the company any slide, color print, or black-and-white snapshot, and they will convert it into a large black-and-white print. There are many ways you can use these to dramatize an area in your home. Here we've taken an old picture and mounted it on Foam Core, which is heavy white cardboard, and cut it out to be free-standing.

Select a picture showing someone full length. If you are going to mount it the way we did here, roughly cut around the figure. Get a large sheet of corrugated cardboard or Foam Core in an art supply store. These are the best materials to use because they are easy to cut. Coat the back of the photograph and the front of the cardboard with rubber cement and let dry. In order to mount the photo so that

Mount triangular supports with white glue.

you don't have wrinkles or bubbles, place a large piece of tracing or waxed paper on the cardboard. This will be your slip sheet. Lay the photo over the slip sheet so that the top couple of inches are actually on the cardboard and are thus cemented together. Slide the slip sheet down as you smooth more and more of the photograph onto the background. In this way you are mounting the photo a little at a time and smoothing it out as you go along. If you make a mistake the photo can be removed with rubber-cement remover and you can then start all over with the application of more rubber cement.

To cut out the figure you will need a sharp craft knife. Don't try to do this with scissors as they will not cut through the Foam Core or corrugated cardboard easily. To stand the figure up, cut a triangular piece and glue it to the back.

You can use this method to enlarge a picture of your pet. Mount it on thin plywood and cut the shape out with a coping saw. This could then become a doorstop.

Photo Collage

The inspiration for this project will come from the photographs that you have on hand. What you pick to use is very personal and the art that you will create will be totally unique. You will use photographic images to make an illustration. Instead of painting you use photographs combined with other photographs for background to create a story. Place the people any way that you want.

Since there can be no step-by-step directions for doing this kind of project we can only give you some tips for success. Keep the composition simple. Try to be conscious of contrast in relation to shapes, colors, and sizes. For the beginner it is best to try one in black and white or do one with a single color against a black-and-white background. Try for texture by combining fabric and other materials to give the composition a bit of dimension. Don't be inhibited by the photographs. Use anything that might work. For example, here we used photos in a collage that suggests the outside and inside of a house at the same time. The house photo is 10 by

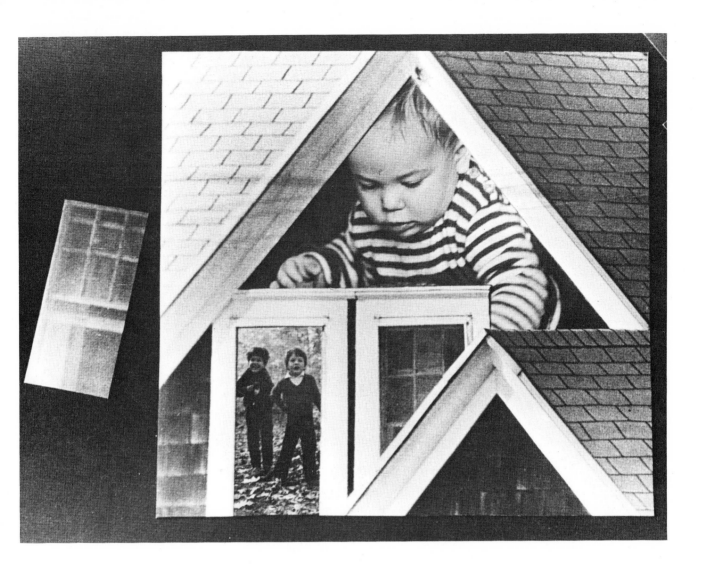

10 inches. By cutting away two sections of the house, the 8-by-10 inch baby's photograph and the snapshot of the two boys fit in to complete the composition.

Dramatize size by contrast. You can cut out a large flower for the dominant object in the collage. Next, cut out small photos of children and place them sitting or standing under the large petals. A photograph of your cat could be sitting on top of a cutout paper mushroom. If you have people in the picture, create a scenic background for them. A girl on a bicycle might be placed against a magazine picture of a road in Italy rather than in the actual street where she was riding. Overlap pictures so that some figures are prominent in the foreground and others are shadowy and in the background. The shadowy figures might be from older photographs of the people in front, representing the past and the present. Then, if you want to, you can even add pictures from magazines showing how these people might look in the future.

Bagged

This project is another version of the photo-transfer ideas that appear elsewhere in the book. (See page 88.) The process is simple. You take a snapshot or 35mm slide transparency to a photocopy center where they make color Xerox transfers. (Check the Yellow Pages under "Copying and Duplicating Service.")

The size of the little cloth bag will be governed by what you want to use it for. It might be made to hold cosmetics, beach accessories, or potpourri to put in your bureau drawers. Determine the size of the bag before selecting the photo. Or if you have a particularly appealing photo that you'd like to use, you can make the bag to fit it. A photograph can be made into almost any size you want when transferred as long as it isn't larger than 8 1/2 by 11 inches.

White cotton or bleached muslin will give you the perfect background for the picture. If you use colorful fabric, you won't be able to see the picture. Flatten out the bag and iron smooth. Take the photograph that you have had transferred to a wax backing, and lay this facedown on the front of the bag. Place a piece of silver foil over it to avoid scorching. Your iron should be set for cotton. Apply pressure while ironing back and forth over the back of the photo transfer. Wait a few seconds and peel the paper backing away from the fabric. You will now have a printed bag with the picture of your choice appearing on the front.

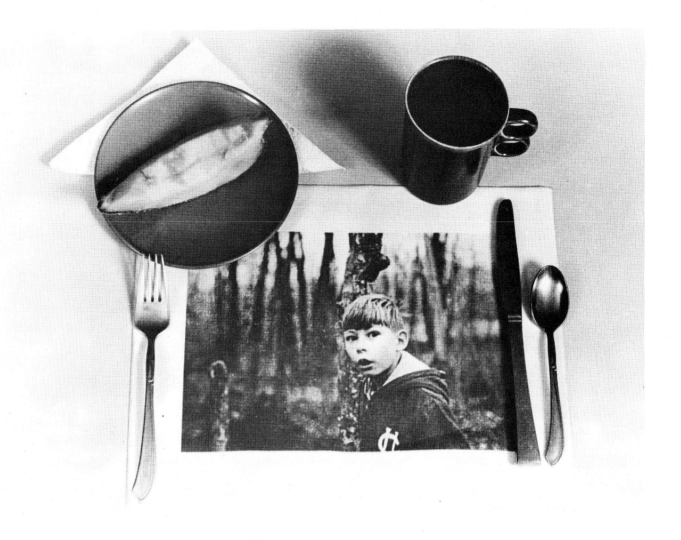

Transfer Placemats

These projects are made using the photo-transfer method. A 35mm color transparency is enlarged to 8 by 10 inches and transferred onto fabric to be made into placemats. Once transferred, the photo is washable but the placemats should not be placed in the dryer. Turn and hem the edges of the mats and press on the reverse side.

Consider turning the cloth mats into plastic placemats in order to keep them soilproof. Cut two pieces of clear Con-tact paper slightly larger than each mat. Put the cloth placemat between the sheets of Con-tact and seal together.

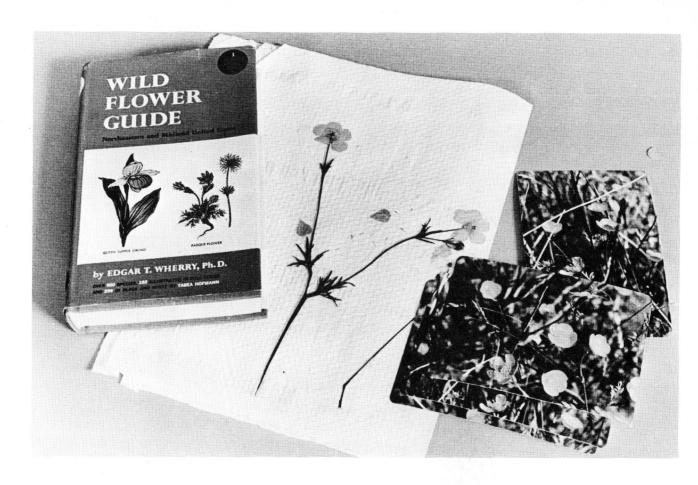

Botanical Photo

The addition of a real specimen can add interest to your nature photograph. If you are taking pictures of flowers, for instance, pick some of the flowers to bring home. While your pictures are being developed you'll have time to press the flowers. Many wildflowers hold up very well and retain their original color. Bright yellow buttercups are especially beautiful for this project.

Lay the flowers on a piece of plain paper so that no two overlap. Try to place the petals so they separate when pressed, so as to get a clear impression of each petal. Place another piece of paper on top of the flowers and load a stack of books or something heavy on top. Leave this untouched for three or four days.

Gently lift the pressed flowers and arrange on a white cardboard backing. Glue down using dots of white glue here and there.

Crop the photograph of the flowers and determine where it will look best on the board. Glue this in place. To finish off this project look up information about the flower in a plant book. Copy it onto the cardboard backing in an appropriate place. You will then have a complete visual story on this flower. If you take pictures of a variety of plant life you can make many interesting arrangements.

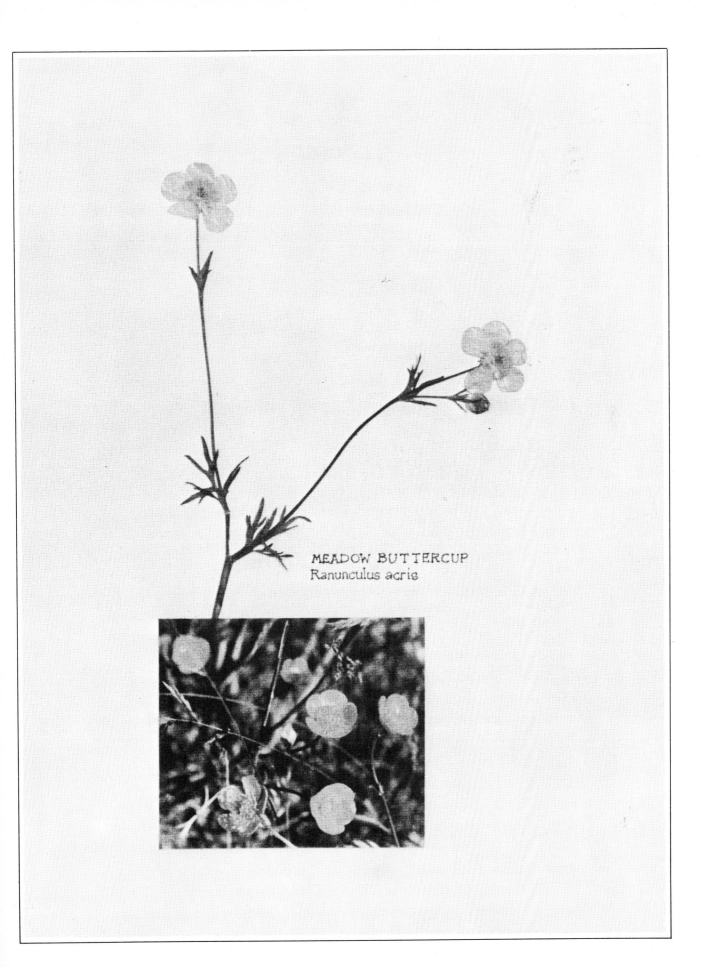

MEADOW BUTTERCUP
Ranunculus acris

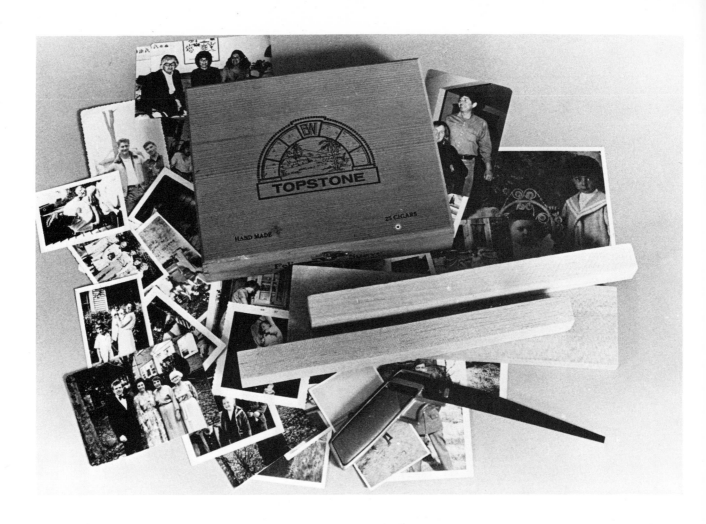

Family Gathering

A traditional family tree is interesting to have but can be difficult to make, especially if you have a large family. An alternate way to document the family is with photos done in this way. Our family gathering is created by mounting small photos of all the members of one family on individual squares of wood. This project can be done in less than a day and the results will bring enjoyment to all.

Begin with a shallow box such as a wooden cigar box or one that can be purchased in a craft shop. The blocks of wood are made from soft balsa that is generally used for model making. It is found in hobby, toy, and five-and-ten-cent stores. It is easily cut with a small saw. Collect all the old photographs that weren't quite good enough for the family album. You can mix black and white with color. If you don't have a picture of every member try to get the missing photos from others. It's amazing how an old, faded photograph of great-grandparents can be utilized by cropping properly. When all the excess paper is cut away, leaving only the faces, it suddenly becomes clearer and more focused.

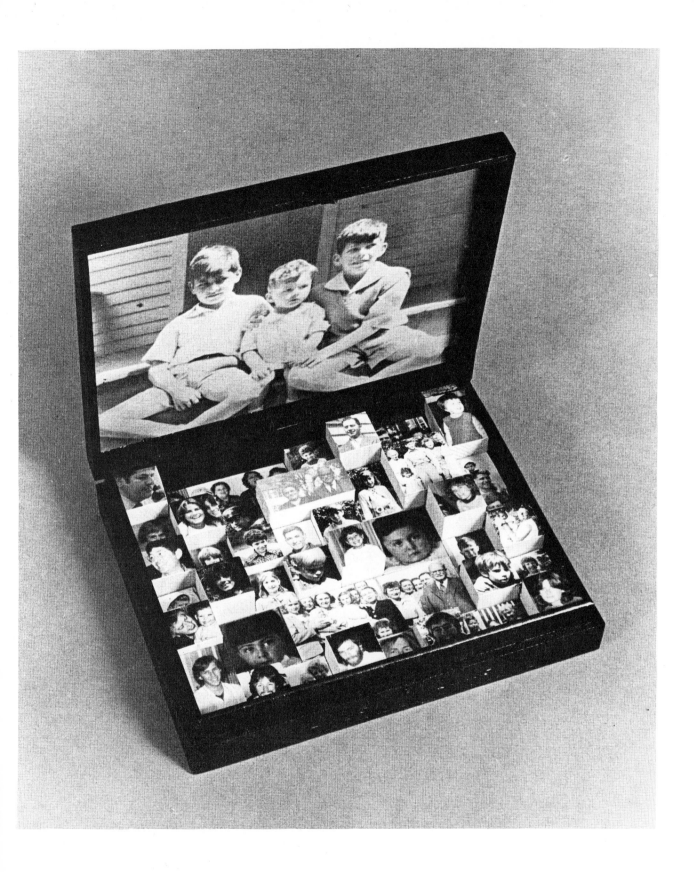

Dry-mount photos with rubber cement.

After mounting, trim edges of photo so they are flush.

Although the wood blocks are cut into all different sizes, most are 1-by-1 inch squares, which makes the placement easy. No preplanning is necessary as the blocks can be arranged as they are made. The blocks can also be cut to different heights, as we've done here, to create interest. When making your final selection of photographs, choose those that you feel would look good on a one-inch square.

Once you have cut several different-sized blocks, place each over the particular photograph to be cut out. Draw around the block and cut that area out of the photograph. Mount the picture onto the head of the block with rubber cement or white glue.

Place blocks around outside edges first.

Glue the one-inch-square pictures around the inside edge of the box to make a border. Now it will be easiest to work inward. Fill in the rest of the box with odd shapes. No real figuring is needed until you get to the end, or center. At this point you will have to play around a bit to make each block fit. It might be necessary to cut a block into an odd size.

Once you have all the photos cut, mounted, and placed in the box, you can begin to move the pieces around until you have the arrangement that is most pleasing. Wait until you are completely satisfied before gluing them permanently in place.

Finish off the outside of the box by painting or staining, whichever you prefer. The outside can also be covered with wallpaper, wrapping paper, or fabric. You might want to put a label with the family name on the lid. The inside of the lid can be lined or you might draw in it a chart with everyone's names. Another idea is to select an interesting photograph to fit into that space so that when the box is opened it is completely filled with pictures. This is a much appreciated gift to give to a family at Christmastime or for any special occasion.

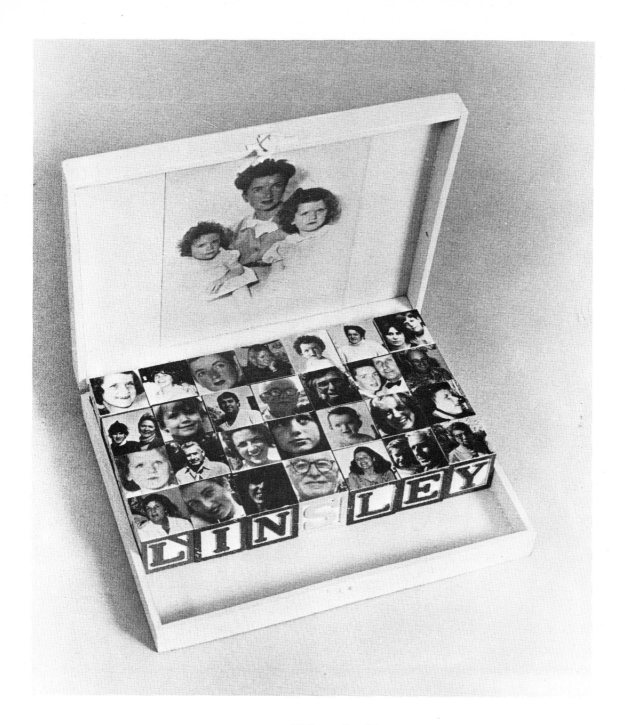

Block Party

This project is a variation on the Family Gathering and takes less time to assemble. Photographs of all the members of a family are cropped so that each can be mounted on one side of a standard children's one-inch square block. If the name is not too long and you have all the letters, use them to spell out the family name. Try to select a box that is the right size to hold the number of blocks you will be using. We used a cigar box, which we spray-painted beige, and we deliberately left space for new members of the family.

Photo Gift Tags

At gift-giving time, rather than spending a lot of money on name tags, create your own. Individualize each package with a different kind of photo tag. They are sure to get attention.

Make a star from construction paper. Fold in each point so that the ends meet in the middle. Open the star up again and glue a photo to fit the exact center. Fold each point in once more and secure with a gummed paper reinforcement. Attach the star to the top of a package.

A pop-up face is easy to make. Simply fold paper to create an accordian. Attach one end to the back of a small photo and the other end to the package. You will have a miniature jack-in-the-box.

Put angel wings on your favorite child. Draw the outline of wings on construction paper. The size of the wings should be proportion-

ate to the picture you are using. Cut out the child's figure from the photograph and glue to the package. Adjust the wings to fit the picture and glue in place.

For simpler tags, make different shapes and sizes from construction paper and crop photos to fit them. Make a hole in the corner with a paper punch and tie to the packages with fat, colorful yarn.

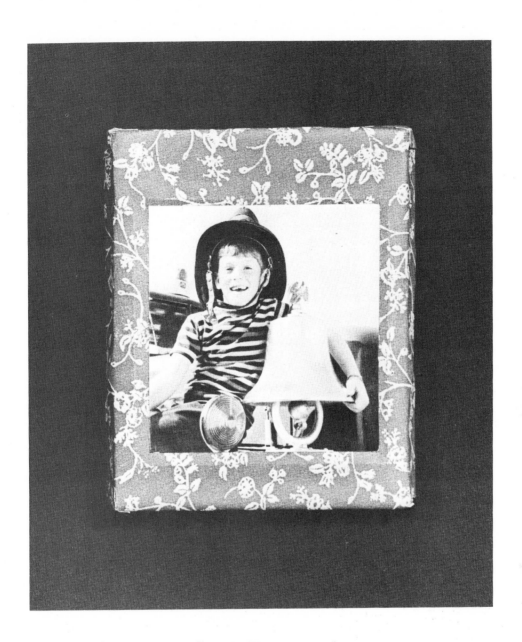

Self-Framed

Don't throw away the Polaroid film holder so fast. It makes a nice, neat little frame for the very picture you have just taken. The black plastic box can be easily spray-painted in seconds. Make it bright pink, fire-engine red, or whatever color goes with your picture. It can also be covered with Con-tact paper or fabric. If you are taking pictures on Christmas morning, use wrapping paper from the presents. Spread white glue on the exposed sides of the package. If the paper is thin, wrap it right around the film package and flatten it to fit without wrinkles by pressing it down here and there with your fingertips. Spread glue on the back of the photo and mount it down on the square panel. Not all Polaroid pictures will fit the area, but for those that will, this is a neat little frame.

Cutting an additional hole in the card

Photo Greeting Cards

If you want to send a photo greeting card here's a clever way to personalize a message. All you need is a snapshot of yourself, a greeting card that strikes your fancy, an X-Acto knife, and glue or mounting adhesive.

Select a greeting card that is suitable for the snapshot. The *Star Trek* card here lends itself perfectly to this project. If your photograph is too large, begin by trimming it to size. In this case, one of the circles is cut out with an X-Acto knife. The photo is mounted inside the card so it will show through the hole. When the card is opened, you see the full snapshot.

To mount the photograph, cut a piece of 3M Scotch Mounting Adhesive sheet to the same size. Peel away the backing and place the adhesive-coated sheet against the back of the photo. Apply pressure to the sheet with the squeegee that comes with it, in order to transfer the adhesive to the back of the photo. Peel the photo away from the sheet and position it inside the card. If it isn't exactly right, pick it up and reposition before applying pressure for a permanent bond. The mounting sheet will give you a clean, neat job, but you can also mount the photo with rubber cement or glue.

Positioning the new photo

Two greeting cards in their original forms

The same cards customized with photos

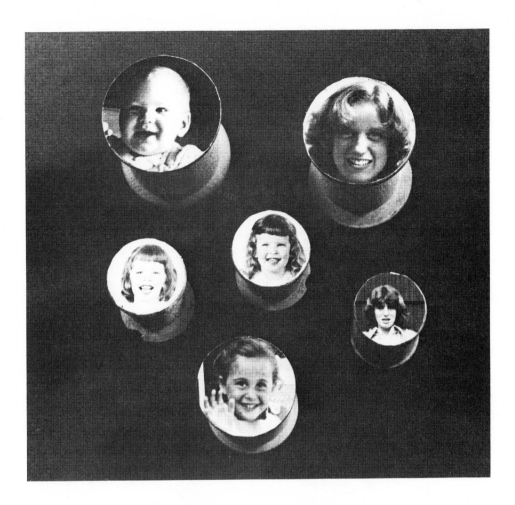

Spool People

For a long time I have tried to figure out what to do with empty thread spools and have always saved them thinking that some day I would come up with the answer. The time has come. Putting photographs on small spool tops is a great way to use those photos that were taken from too far away.

Place each spool over the area of the photo to be used, and draw around it. When cutting go in a little from the line and try to keep a nice even edge. I found that cuticle scissors worked best.

Coat the back of each circular photograph with rubber cement and let dry. Do the same with the top of each spool. Dry-mount the photos to the spool tops. They will look almost comical, as though the heads should somehow have bodies attached. You can leave the wood natural, as I prefer, or paint it black with acrylic or spray paint. Remember to do all painting before mounting the pictures.

These spool people can be mounted on the wall in an appropriate arrangement depending on how many and what sizes you have. Or you can place them in a box decorated with a collage of photographs or painted and finished with a label.

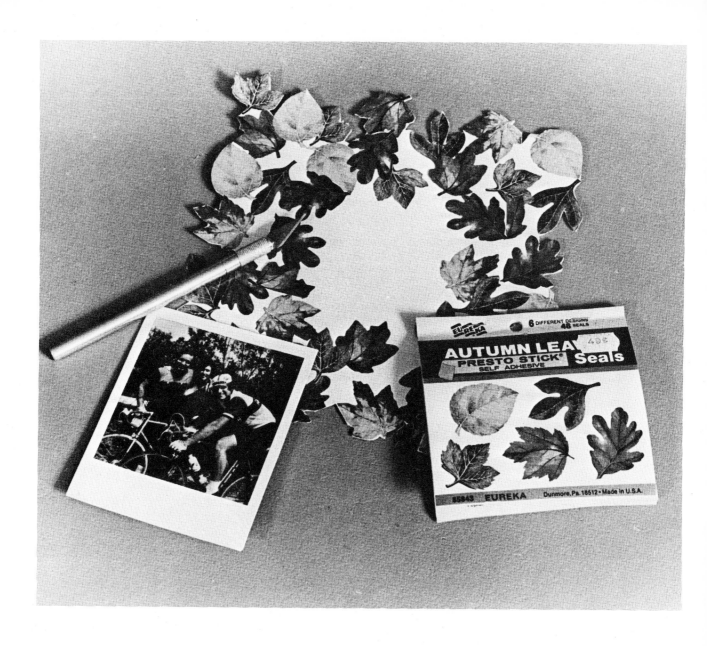

Surrounded by Leaves

This picture of three bicycle riders dressed in bright fall colors reminds me of fall. And this suggests a framing idea that you can easily adapt for one of your pictures. Again, a simple photograph can be turned into something special for display.

The leaves that surround the photograph are all from one pad of self-adhesive stickers purchased in the five-and-dime for under fifty cents.

Draw an outline of a frame on cardboard. This is a 3 1/8-by-3 1/8 inch picture, and a two-inch border around it should look good. Do not cut the frame out. Place the stickers all over the area so that many of them overlap the outline here and there. Some

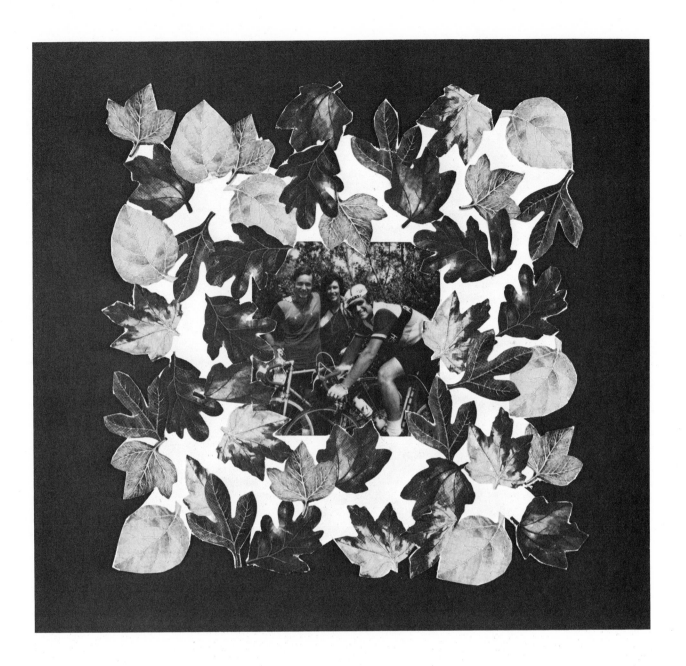

should also overlap the center lines as well so that they will come over onto the picture when it is inserted. Have your photograph nearby while you are working so that you can refer to it and will avoid placing any leaves so they overlap someone's face.

When the area has been filled in, or you are out of stickers, cut the frame out. Use scissors and a razor blade for tight areas. You will then have a free-form mat or frame for the photo. Cut away the center area in the same way. Cuticle scissors are often good to use for this step in order to avoid a choppy look.

Place the photograph behind the center space and hold with masking tape. You can hang as is with self-adhesive tabs or make a stand so that it can be placed on a table.

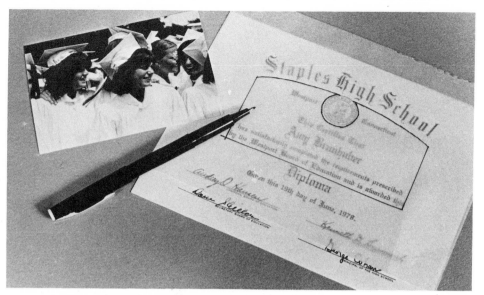

Tracing of the area to be covered by photo

Use the tracing to crop the photo.

Graduation

Diplomas or certificates of graduation or other achievements can be a wonderful background for a photograph of the recipient—and a unique gift.

In order to keep the original diploma intact, begin by having a positive photostat made of it. The photograph is then mounted to the photostat and the diploma is not used. To have a photostat made, take the original to a local copy center that provides this service. Check your Yellow Pages for photostat services. It will cost between two and three dollars. The photostat will be an exact replica of the original and will be crisp black and white, unlike a Xerox copy, which is dark gray. The paper will also be thicker and shiny. When the photo has been mounted in place with rubber cement it will look just like the original.

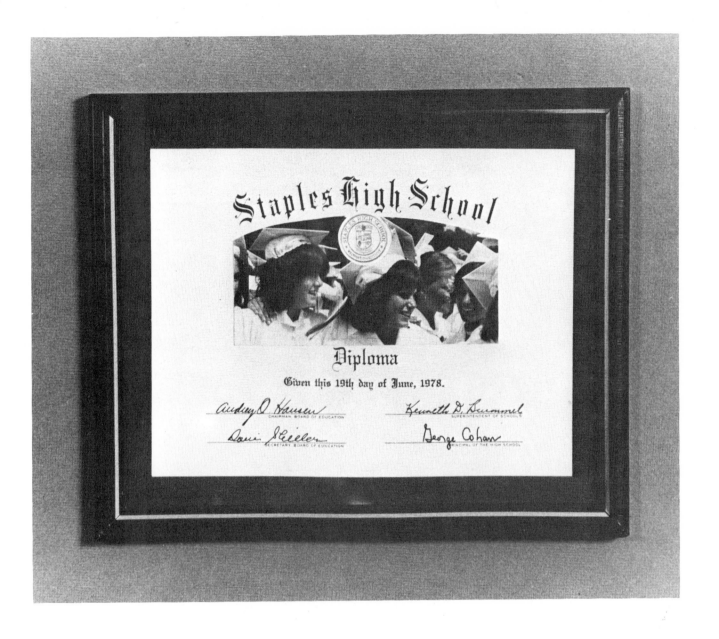

Make a tracing of a section of the diploma in order to find the best position for the photograph and then select a photo that fits the area to be covered. In this case we wanted to leave the name of the school and the official seal exposed at the top. Therefore the photo was cropped accordingly. Adjust the photo to suit your particular document and mount it with rubber cement. A thick black frame will finish off the project. If the diploma is an odd size and you cannot find a frame to fit, you can mount the whole thing on mat board cut to the right size. Choose the color mat board that is suitable for the photograph. Black or white will probably look best. Mat board is available in an art supply store or framing shop. For mounting, always use rubber cement rather than glue. In this way you can reposition if you don't do it perfectly the first time.

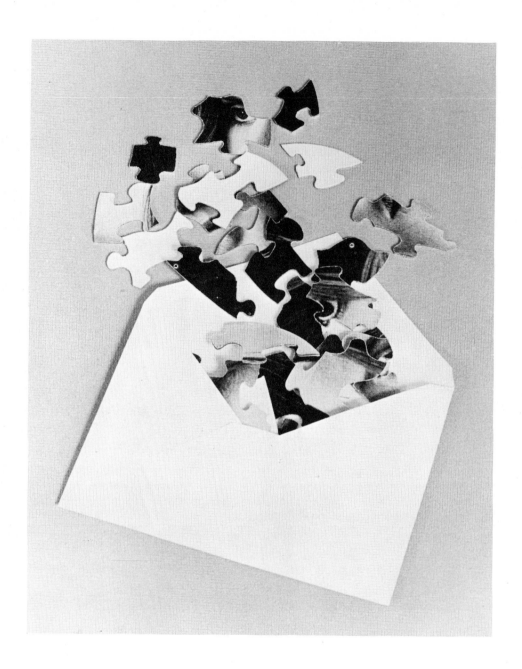

Puzzled in Love

A photo puzzle made for your favorite valentine can carry with it a personalized message and your photograph. It's a unique and entertaining gift. It's easy to make, inexpensive, and unusual. Mount a large photograph of yourself on colorful posterboard available in the five-and-dime. Trace the heart-shaped outline and the jigsaw pattern reproduced here onto tracing paper. Next place the tracing, pencil-side down, over the face of the photograph you have chosen to use. With a soft pencil, transfer the outline and cut lines onto the photograph by going over the lines on the tracing sheet. Remove the tracing. Write a message on the back of the poster-

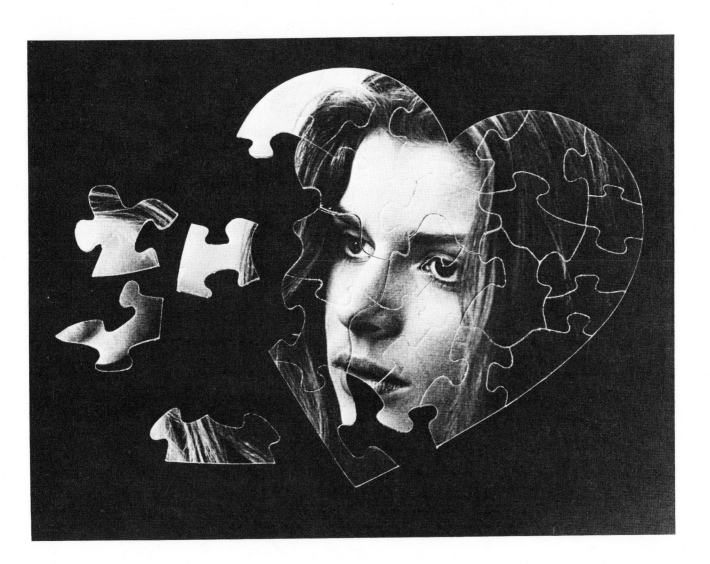

board. With a sharp razor blade or craft knife cut through the photo and posterboard on all lines. Hold the knife straight up and down and apply pressure. The knife blade must be sharp so that it doesn't pull when cutting, creating choppy edges. This takes a little care and patience but is not difficult.

When all the pieces are cut apart, take an emery board and smooth the rough edges of each puzzle piece. Put the puzzle together to make sure each piece fits together well. Take the puzzle apart again so that you can put the pieces into an envelope for sending. Colorful envelopes are sold in art supply stores as well as stationery departments.

This could be a lovely idea for a Mother's Day present as well. Or perhaps you have a large photograph of your children that could be mounted and given to their grandmother as a birthday present. If you have smaller snapshots you can make a miniature version by drawing your own jigsaw pattern before cutting up the mounted picture.

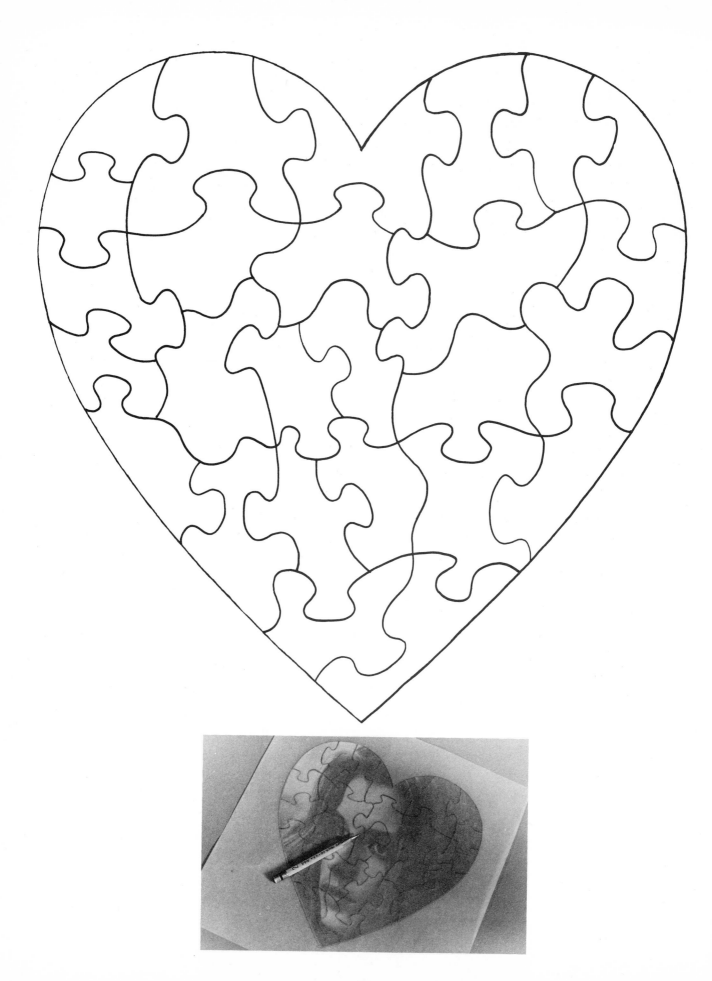

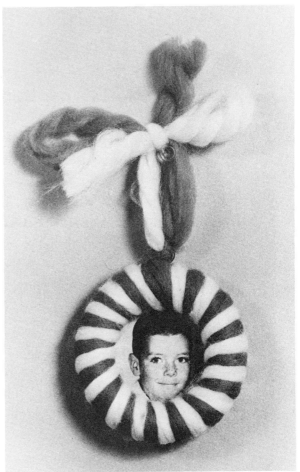

Ring Around the Photo

Fat wooden curtain rings come in packages of six or eight. Each ring has a little round screw-eye at the top for hanging. The curtain rings make excellent small frames. They can be painted and are easily hung with nylon thread, picture wire, or yarn. For the project shown here you will only need the ring, a photo to fit, two pieces of yarn in contrasting colors, and glue.

Put a drop of glue on the back of the ring at the top. Place the two ends of each strand of yarn on the glue to secure them. When dry, twine them around and around the curtain ring, pulling tightly as you go. When you get back to the top, thread the yarn through the little ring and tie for hanging.

Place the ring over the area of the photograph you want to show and draw a circle around it. Cut this out and trim it to be slightly smaller. In this way the edges will not be seen from the front. Put a little glue around the photo and place the curtain ring down on it so that the photo shows through. These photo rings make unique Christmas ornaments.

Rookie of the Year

If you have taken any snapshots of your son or daughter or a friend's child playing in a sports event, this project is the perfect way to put him or her in the Hall of Fame. The picture used here of our baseball player was easy to adapt. The baseball cards are particularly graphic, are sold in many stores, and are the perfect size. Of course, you may have to buy a lot of bubble gum along with them, but we found them packaged without the gum.

Crop the photograph to fit on a baseball card, leaving a border around it so that it will look authentic. Next, mount the selected baseball cards on a background of black mat or posterboard. Use rubber cement so if you place one crooked or in the wrong position you can easily lift and reposition it. For added effect the photograph of the child is projected out from the background. To do this, glue several small pieces of cardboard together and onto the background. Corrugated cardboard is the right thickness to create enough space between the background and photograph. Glue the center photo to the little stack of cardboard.

This project is now ready for framing or can be hung as is with the use of self-adhesive tabs or hanging clips attached to the back of the board. For framing, remove the glass and, if desired, spray-paint the frame to match a dominant color found in the cards.

This is an inexpensive wall decoration for your child's room. You can do this with a picture of a child in a play, surrounding him or her with pictures of other stars. Or you can create a montage of your child's heroes with the child's picture in the center. You might use portraits of famous people, perhaps the presidents. And you can make this project for grown-ups too. Just use your imagination as to what category of pictures to use with your snapshot.

Blue Jays — JERRY GARVIN

Giants — DARRELL EVANS

Expos — ANDRE DAWSON

Pirates — PHIL GARNER

A's — JERRY TABB

Mariners — LARRY MILBOURNE

Yankees — SPARKY LYLE

Blue Jays — OTTO VELEZ

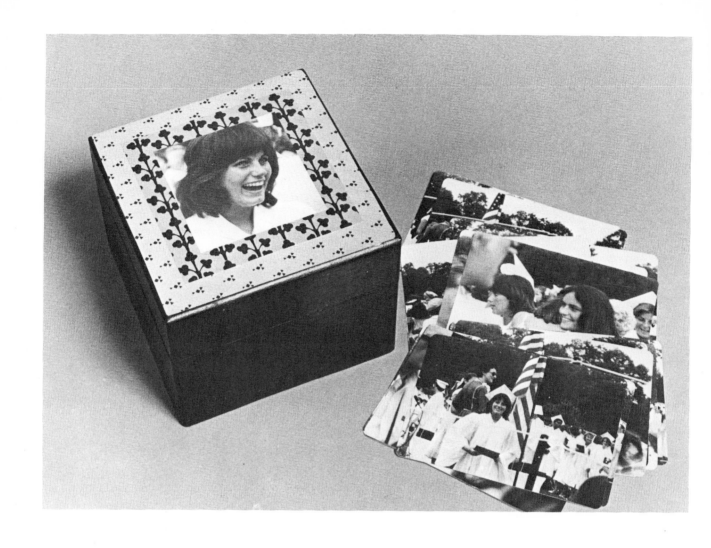

Memory Box

For those of us who never seem to have time to paste photos in albums a photograph box is the perfect solution. Unfinished wooden boxes come in many sizes and can be found in hobby shops. Select one that is large enough to hold your photos. Or you might have an old box that can be repainted, stained, or covered. As you collect the photographs just throw them into the box. Eventually, you will have enough so you can stand them on end, as in a file box, for easy viewing. Finally, when you feel ambitious, you can sort them and arrange them in chronological order.

Begin with two pieces of wrapping paper or wallpaper that look good together. Cut one piece so that it fits the top of the box. Mount this to the box with glue or rubber cement. Next, cut a slightly

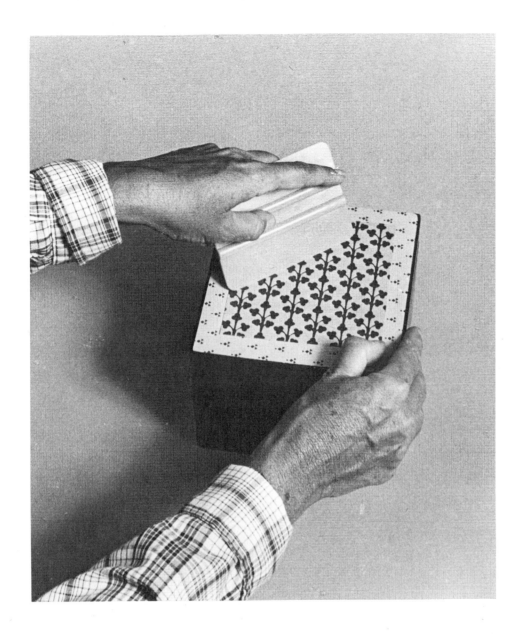

smaller square from a contrasting paper. Mount this to the top also, over the first piece of paper. Trim the snapshot you have chosen so that it fits in the center of the paper, leaving a thin border on all sides. The inside can be painted or lined with one of the colorful papers used on the top. Sand the inside smooth before applying paint or paper.

For a novel wedding present, you can mount the bride and groom's picture on top and fill the box with wedding pictures. The girl shown here is a recent graduate and the box holds pictures of her classmates, her own school pictures over the years, and a well-documented photo story of graduation day and the senior prom.

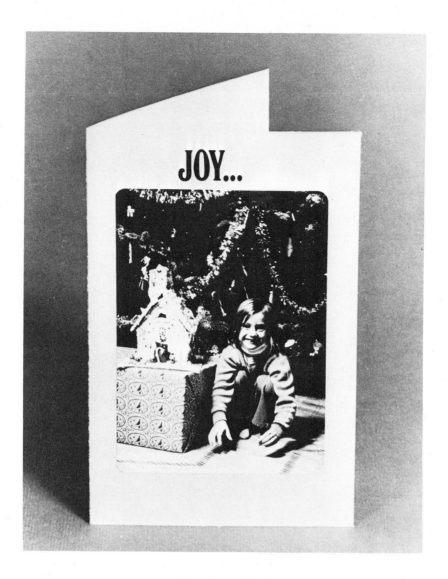

Christmas Wishes

Make your own photographic greeting card by having your favorite picture made up in your own design. The examples shown here were created especially for these wonderful photographs. Making your own card from scratch is more original than simply taking the snapshot to the camera shop and using their design. In this way you can decide on the size, style, layout, and saying to be included.

Decide on the size you want and do a sketch of your idea. Look through your photos for inspiration. You may want to take a picture to express an idea you have.

The easiest way to do the lettering is by hand. For special effects use press-on letters to express *JOY* or whatever, such as was done here. Press-on alphabets such as Presstype are available at art stores and come in many styles and sizes. Do your lettering on a piece of paper and set aside.

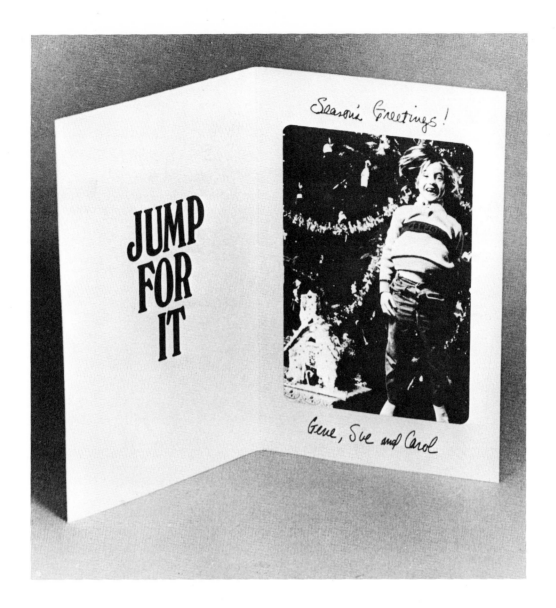

On white bond paper draw a rectangle to the size of the card, indicating where it will fold with a little mark in the margin. Mount the lettering in the correct position with rubber cement. Decide where the photograph should be placed and make corner marks on your card background. These dots or lines should not be visible when the photo is placed over them; they will simply be a guide for you to follow after the cards have been printed. Consider making a border around the photo. This can be done with a marker or fine pen.

Take your artwork to a printer. There you will be able to select the color and weight of the paper you want for your cards. The printer will be printing only the message and border you have drawn. If you want to supply your own cards, you can buy blank, colored cards and matching envelopes. These come in a variety of

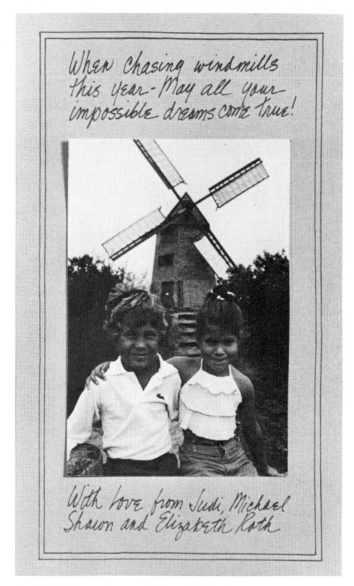

When chasing windmills this year—May all your impossible dreams come true!

With love from Judi, Michael, Shawn and Elizabeth Roth

A delightful greeting card from the Roths

wonderful colors and can be found in art supply or stationery stores. Take these, with the art, to the printer.

Have as many photos as you will need developed in the right size from your negative. When you get the printed cards back from the printer you can mount each photograph in position on the card. The marks for easy positioning will be printed in exactly the right spot. In the "Jump for Joy" card we used two photos in order to get the concept across. If you don't have a photo that might work for an unusual idea, try setting up one especially for that idea.

Sometimes a photograph taken in the summer is just the right picture to send with your message at Christmastime, as with this picture of the children in front of a windmill.

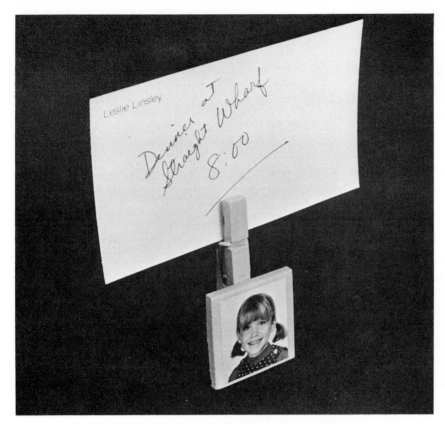

Tile Note-Holder

To make this desktop note-holder costs practically nothing and you can easily make several at a time to give as gifts.

The materials needed are one small bathroom tile, available in hardware or bathroom supply stores, a wooden spring-type clothespin, acrylic or craft paint, and a photograph. School photos are perfect.

Begin by painting the clothespin and tile in the color of your choice. Acrylic paint comes in small tubes in a variety of colors and is available in stores where art supplies are sold.

Trim the photograph so that it will fit on the front of the tile with a little border all around. Be sure the paint is dry before mounting the photograph to it. Spread a little white glue on the back of the photo and press it to the front of the tile. Let this dry for a couple of minutes. Next, spread glue on the bottom inch of the clothespin and secure the tile to this. Leave it untouched for at least a half hour.

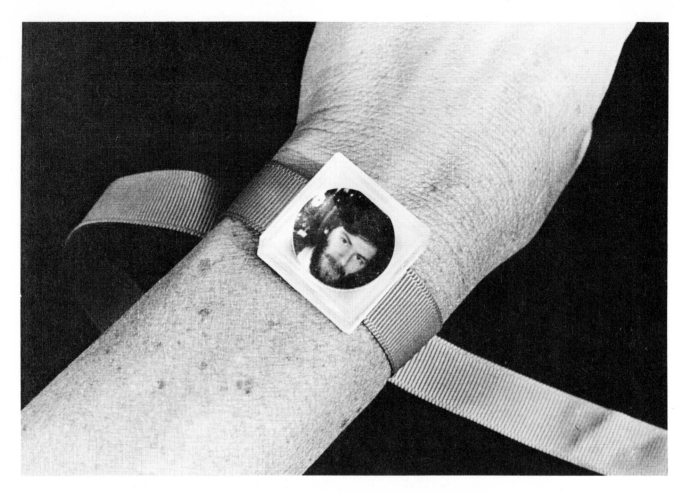

Watch Someone Special

For centuries women have carried a picture of their loved one in little lockets hanging around their necks. This photo wristband is an updated version. Not quite as close to one's heart but more easily visible.

The wristband is made with a tiny "bug" box and a ribbon. These little plastic boxes are sold in novelty and dime stores for holding and inspecting bugs through the magnifying glass that makes up the box lid. Remove this lid and place it over the head of your photo. The person's face should fill the area. Cut this square area from your photograph and mount it to a small piece of cardboard.

Apply white glue to the rim of the box lid and place this over the photograph. Your special person's face will be magnified. Select a pretty grosgrain ribbon that is approximately three-eighths inch wide. Buy just enough to tie around your wrist. A half yard should be more than adequate. Find the center and squirt some white glue on the area to be covered. Place the box top-down so that the cardboard backing is attached to the ribbon. When it is dry, it is ready to tie around your wrist.

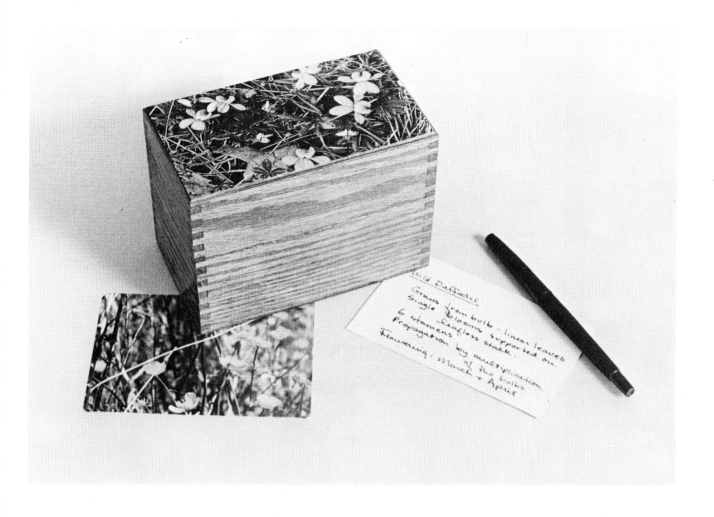

Nature Study File

If you have an interest in birds or flowers or marine life you may have taken many pictures that you would like to have on file.

Create a file of specimens that you have observed. Assemble the photographs alphabetically or according to category and fill in all the data about each on a file card. Mount this to the back of each photograph. This then becomes your file and can be easily referred to.

Use a metal or wooden recipe or file box. The one used here was stained darker than the natural wood to give it an earth tone. You might prefer painting the box, or you can leave it as is. File boxes in metal and wood are available where stationery and office supplies are sold.

Select a favorite photograph that can be cropped to fit the top of the file box and mount it in position. If you would like to protect the photo as well as give the wood a rich glossy finish, a coat of polyurethane varnish can be applied. Let this dry overnight.

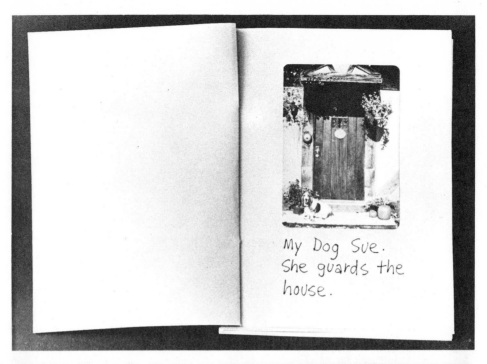

My Dog Sue. She guards the house.

Sue can sit
Amy showed her how.

Michael shows Sue a trick. She learns fast.

A Child's Storybook

A young person can, with a little help, create a storybook. To do this you will need a variety of photographs relating to a simple story that can be made up to go with them. We had an overabundance of pictures of the family pet, taken at different times—the result, a story about "My Dog Sue." The photographs that you have on hand might be used to create a book called "Friends," "My Summer," "Camp," or "My Party," to name a few.

Sue is a
good
wrestler.
She can
beat me.

On Sue's birthday
I made her a
daisy chain.
This is it.

The thing that
Sue does better
than anything
else is

S L E E P !

Each page in the book is half a sheet of construction paper. Assemble the photos in order and mount one to each page using rubber cement. Use as many pages as needed to tell the story. The booklet is created by punching holes at the edge of the papers and tying them together with yarn. The lettering can be done freehand with markers.

This project might be enjoyable for a child to do on a rainy day or when sick in bed as the materials are usually found in the home.

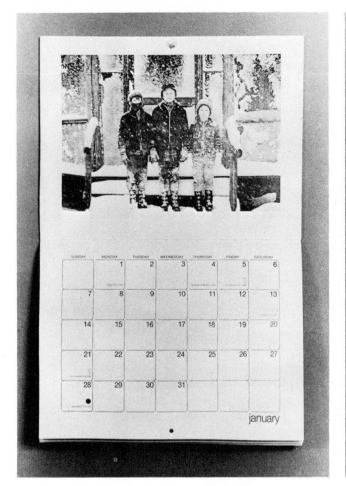

Picture Calendar

If you enjoy taking outdoor scenes in different seasons, you can create your own calendar. Why spend each month looking at a scene taken by someone else when you can have a personalized calendar?

Buy a calendar like the one illustrated. The pictures on the calendar should be no larger than 8 by 10 inches. They will be covered by your own pictures.

Look at the photographs that you've taken throughout the year and decide which best represent each month. Consider taking pictures with this project in mind. For example, the calendar with photos of the three boys combines the idea of seasonal pictures and family memories. The three boys were photographed outdoors each

month of the year in a situation that expresses the feeling of the season. This calendar is one that will be kept for many years.

Photographs of nature topics are fun to take and the calendar is a good way to put them to use. Daisies in the spring, a frog in summer, dried leaves in autumn, ice crystals on the trees in winter are a few suggestions. Take pictures throughout the year for next year's calendar.

Color prints can be made to any size from color negatives and slides. Black-and-white prints are also effective. To make the calendars shown above we used color Xerox enlargements because they are less expensive than enlarged color prints. Of course, you can make your own calendar to any size you want depending on your photographs.

Four photos can fit on one color transfer sheet.

Gift-Wrapped

Blowup pictures of friends and relatives can be transferred to shiny white wrapping or shelf paper for a unique way to wrap a package. It's easy to have this done and can create a lot of excitement around the Christmas tree. Nobody will want to throw away the wrappings.

Your photographs or slides can be transferred to a wax backing which is then transferred to the paper. It is done on a special Xerox machine, available at most copy centers, and will cost about two dollars. Check your local Yellow Pages for a center near you.

Sizes range from 8 1/2 by 11 inches down to the exact size of your photograph. Therefore, you have plenty of leeway for your packages.

The transfers will come out best if the original photograph is sharp; or, in the case of a color slide or snapshot, if the colors are bright. A dark, dull photograph will come out darker, duller, and harder to distinguish. To fuse the transfer to the wrapping paper, place the paper on a countertop with the shiny side up. A dish towel or similar cloth placed between the countertop and paper may help you do the next step without crinkling the paper. For transferring onto material an ironing board is always used, but you might crease the paper if you do it this way. Therefore, you have to experiment

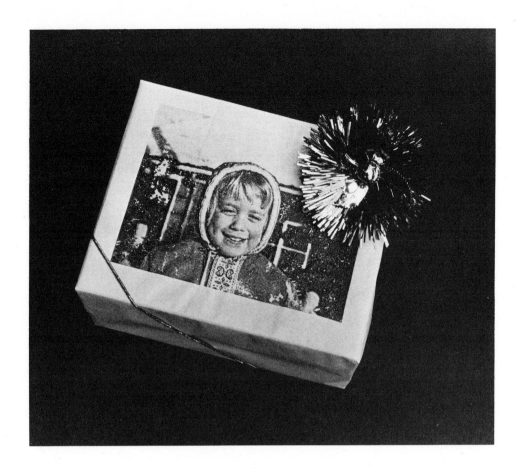

a bit. Center the transfer facedown on the area of the paper desig-
nated for the photograph. Put a piece of silver foil over the back.
Set your iron at medium hot and apply pressure to the foil-covered
transfer. The foil will prevent scorching of the paper. Test to see if
the art is transferred by peeling back a corner of the paper. If it isn't,
your iron isn't hot enough. When properly heated and enough
pressure is applied, the transfer will peel away easily, leaving the
picture on your wrapping paper.

You can have one enlargement made and transfer it to the paper
for a complete package covering. Or you can have several small
transfers made for the same amount of money. In this way you can
create an overall pattern repeating the same photograph of one
person, and have wrapping paper that looks as though it had been
printed. It could even be framed.

Experiment with different transfer ideas on fabric and paper. You
can even use plastic if you are careful. I have never tried this on
wood, but it should work equally well. Once you do it a few times
the results will be so good that you'll be inspired to think up other
uses for this technique.

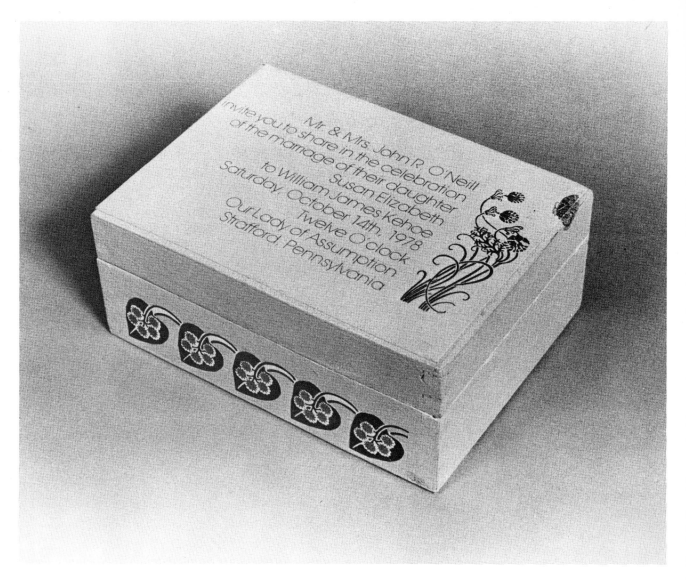

Mr. & Mrs. John R. O'Neill
invite you to share in the celebration
of the marriage of their daughter
Susan Elizabeth
to William James Kehoe
Saturday, October 14th, 1978
Twelve O'clock
Our Lady of Assumption
Strafford, Pennsylvania

Wedding Box

A wedding box is a slight variation on the Memory Box (p. 136) and can be used for holding other things besides pictures. Take the wedding invitation to a craft shop to find a wooden box that it would look appropriate on. The box needn't be the exact size, as the invitation can be trimmed. But it should be proportionally well suited. If you have a cigar box or something similar, you can use this.

Begin by sanding and then painting the box in a delicate background color. White is always appropriate and the invitation and other decorations will look fine against this. Acrylic paint comes in small tubes and dries quickly. If you don't already have indoor house paint around, buy a tube of acrylic. A sponge brush is inexpensive and perfect for this kind of project. These are available in hardware stores for under fifty cents.

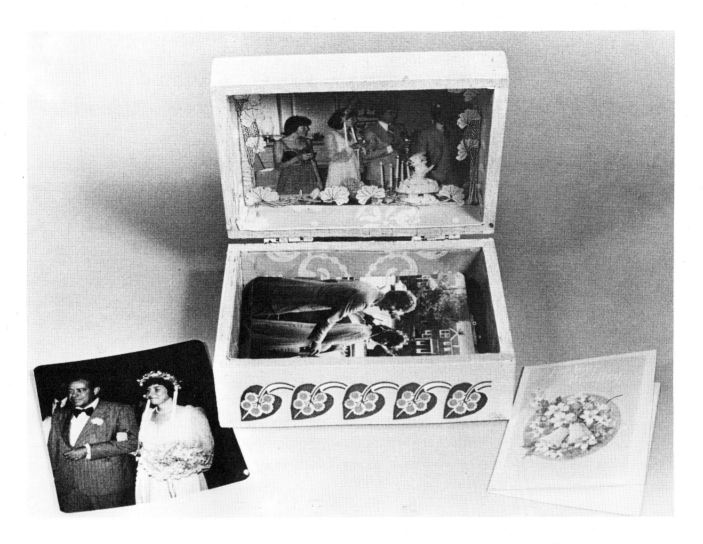

Paint the box inside and out. Don't forget the inside edges. When it dries it will probably need a second coat. The sponge brush can be washed and used later for varnishing the box. Sand the painted box lightly with very fine sandpaper.

Next, glue the invitation in position on the top of the box. If you want to soften the edges add cutout flowers or other pleasing designs where appropriate. These can be cut out of a book, from wrapping paper or greeting cards or similar sources, and glued around the invitation. Some can overlap onto the sides and front of the box for added interest. Make sure that the invitation and designs are secure by rolling a pencil or similar object over the whole thing. This will force the excess glue to ooze out from under the paper; wipe it away with a damp sponge.

The inside of the box can be lined with wrapping paper or with velvet for a more elegant look. If you prefer, it can be painted with another color or left as first painted. The paper lining, though, is quite nice especially if it continues the design that you applied to the outside.

A wedding picture of the bride and groom makes a delightful liner for the inside lid. If it doesn't fit quite right, you can make adjustments. Either cut it down to size or, if it is too small, add cutout designs here and there to fill in the area. Again, attach this with white glue.

Finally, the entire box, inside and out, should be coated with an indoor wood varnish. For this project I recommend a matte or satin finish which has a low luster. Purchase this in a hardware or art supply store. You will need a pint size. Since it has an oil base you will also need some brush cleaner such as mineral spirits or turpentine.

The varnish should be applied in an even, thin coat and the lid must be propped open slightly to allow air to circulate on the inside. Do not prop it too much or the varnish will run while drying and cause drip marks. Let the box dry overnight. Repeat the varnishing for five or more coats in order to submerge the designs (if you have used a photograph on the inside lid cover with one coat of varnish only). After five coats, sand the surface lightly. Be sure to allow each coat of varnish to dry thoroughly before reapplying. In this way you will have a smooth, hard surface and the designs will appear to be part of the box. If you have painted with white acrylic the varnish will yellow it slightly, giving it the look of ivory. This is very appealing, eliminating the chalky whiteness.

A piece of felt can be glued to cover the bottom to protect the tabletop and your box is finished. Fill it with photographs or give it as is.

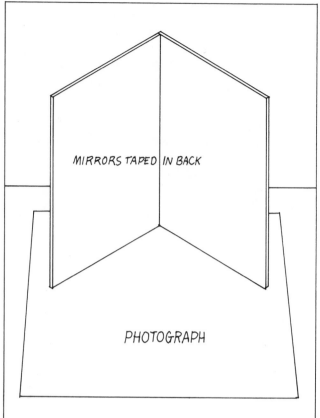

MIRRORS TAPED IN BACK

PHOTOGRAPH

Photoscope

This project that takes no time at all to make is fun to display on a table where everyone can enjoy it. You will need two mirrors of the exact same size. A good size is 4 by 6 inches and you can have the mirrors cut at the hardware store or glass cutter's. Often they will have scraps left over from larger jobs and might even give them to you for the asking.

Lay the two pieces of glass facedown side by side. Using cloth tape such as Mystik, tape the seam joining the two pieces of mirror. This will give you a hinge. Set a photograph on the table and arrange the mirrors so they stand at one edge of the photo. Open and close the hinged mirrors, to get the right angle to create several images of the photograph. Some angles will give you four images, some will give you a kaleidoscopic effect. If you have taken any action shots this is a good way to display them. This diver, for instance, twirls over and over, around and around, in the images created in the mirrors. Change the photo from time to time for variety.

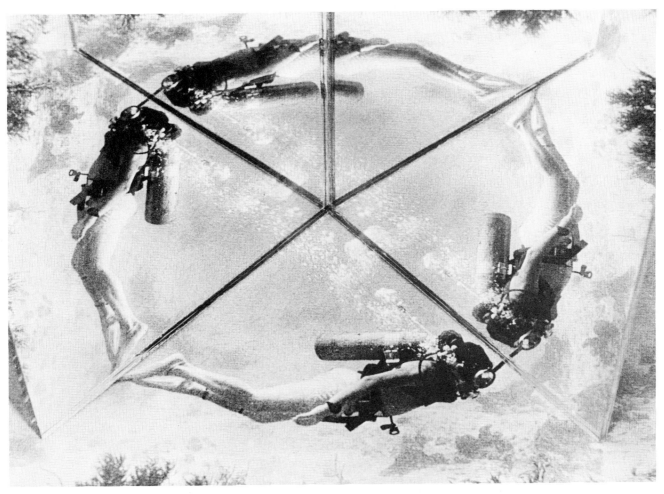

Mirrors are hinged with tape so they can be adjusted for different pictures.

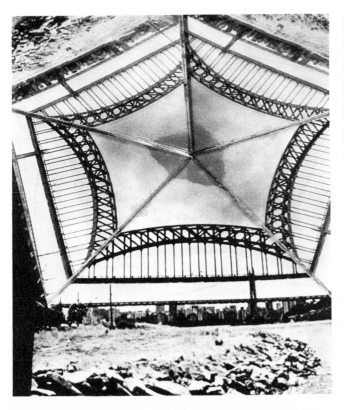

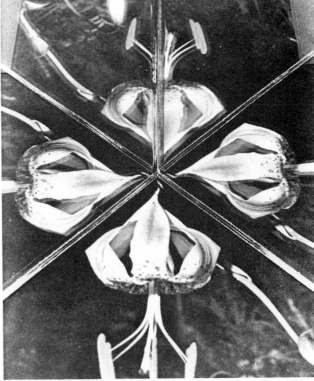

A Full House

The entire family rarely lives together in one house. In fact, it is rarely possible to gather together every member of one family in order to take a family picture. Therefore we have provided you with a means of doing this without having to invite a single person to come over. What you do need, however, is a picture of everyone taken separately, even on different occasions in different years.

The house that appears here can be used as is by having a copy made from the book. As most photographs are too big to fit on the small drawing, however, you will need a photostat that enlarges the size by about two times. Take the book to a copy center that makes

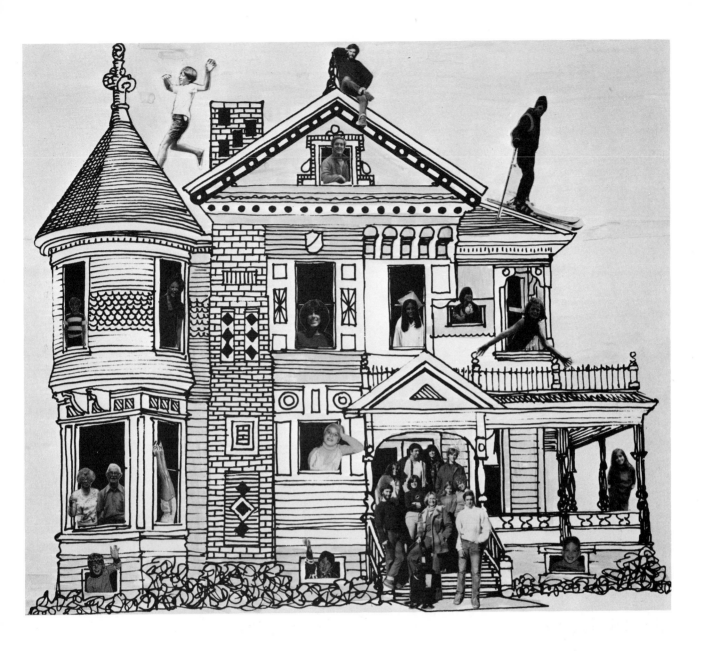

photostats. (Look in the Yellow Pages for this service.) Tell them to what size you want the picture enlarged. You will get a crisp black-and-white enlargement for about three dollars.

Mount this to a cardboard backing with rubber cement. From all the assembled photographs of your family and pets, cut out the figures and arrange them on the background. You can cut out windows and doors in order to have people sticking out here and there. Place someone coming out of the doorway or walking up the path. Sit someone on the roof or have your pet peering out of the window. It could be a fantasy scene in which nothing is realistic. The effect of your efforts will depend on the photographs you use, how crea-

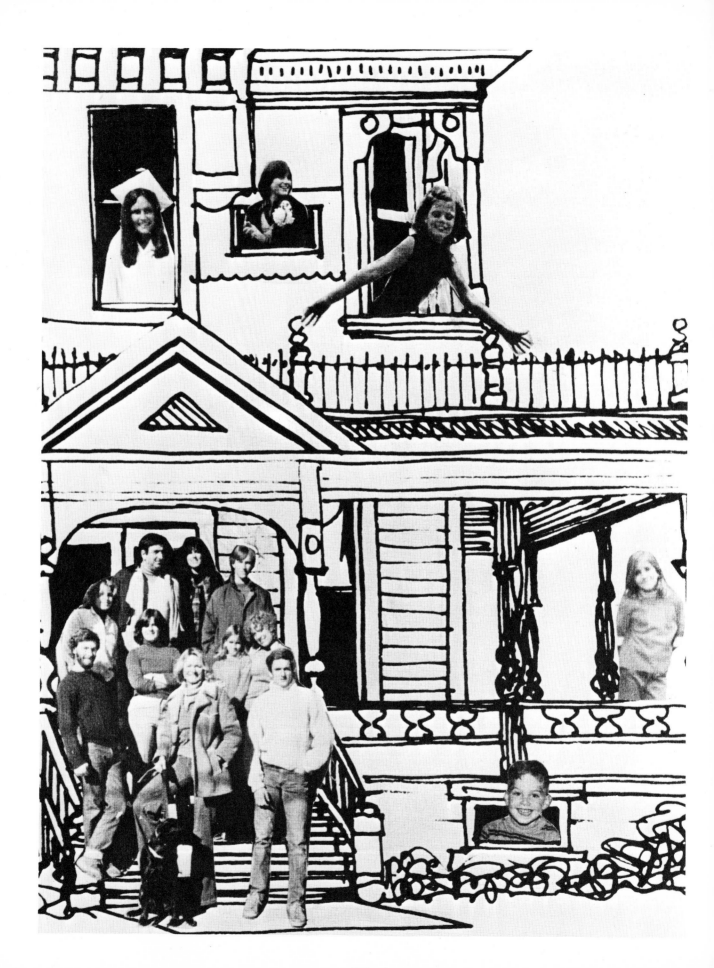

tively you cut them out, and how you place them. Once you have decided where everything should go, glue each down with rubber cement or Elmer's glue. Create a decorative border with mat board. Check the matting projects for some unusual ways to do this. Select an appropriate frame and you then have your entire family assembled for one photograph.

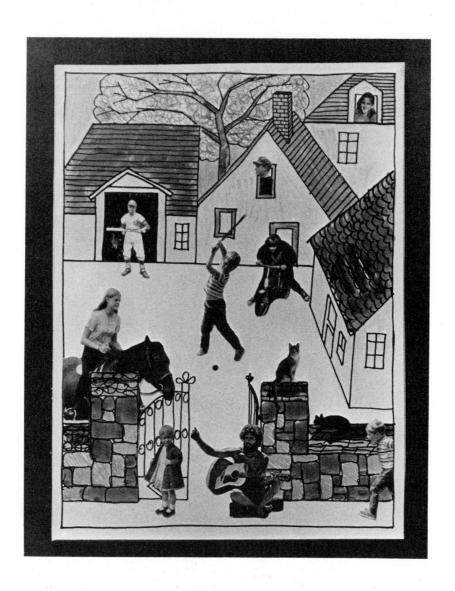

Fantasy Scene

The first tricycle ride, sitting on top of a fire engine, sitting behind the wheel of the car at age five, or atop a horse, are exciting moments that we capture on film. You can create a fantasy scene as a background for such photos.

The artwork provided here can be used for a variety of pictures. Trace the picture background from the book (or make a photostat) and transfer it to a piece of white posterboard. If you prefer, you can find your own scene, which might come from a coloring book or similar source.

Color in the picture with different colored markers or crayons. Next, cut out the picture so that there is no surrounding area left. Coat the back with rubber cement and let dry. Put rubber cement on the area of the background art to be used. Dry-mount the picture in place and smooth down.

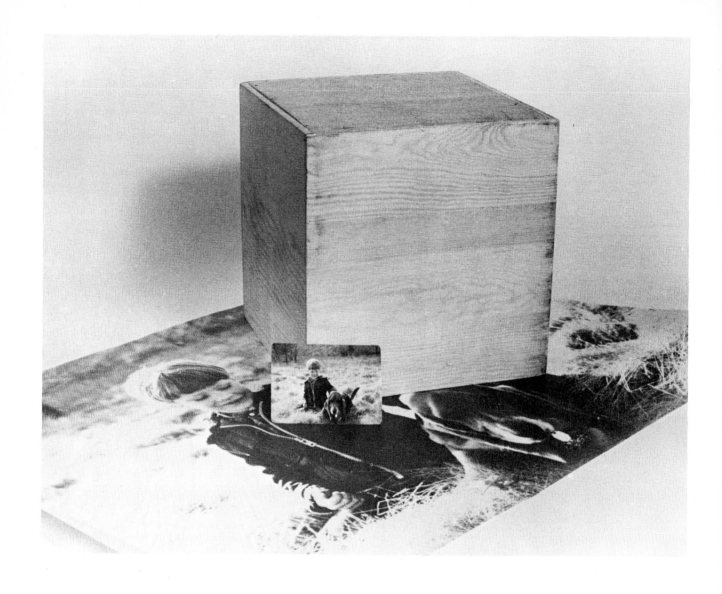

Display Table

Storage cubes made of raw, unfinished wood can be purchased in several different sizes. They are standard items in stores that carry unfinished furniture. When decorated they make unusual yet inexpensive tables.

A 24-by-36 inch photo is mounted on a cube that is 12 by 12 by 12 inches in such a way that the exposed surfaces are covered. Select a horizontal picture to be enlarged. The photograph must work correctly on the cube. (See photo and diagram.) In order to make sure it does, you'll have to take some time to study your photos so that you can imagine what one might look like when cut to fit the cube. If you look at the diagram, this will give you an idea of how your photo can best be utilized for this project.

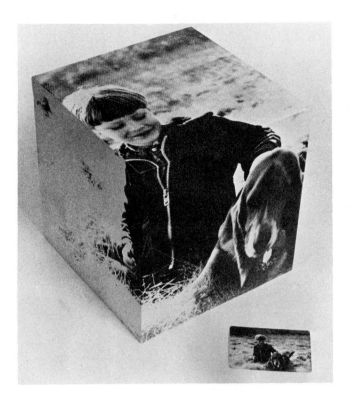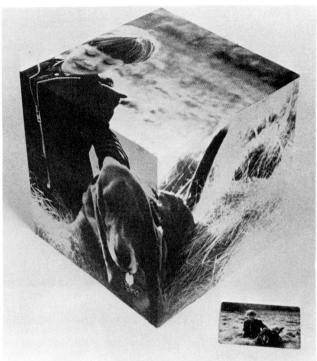

When you have selected a photograph to be enlarged you can send it away to have this done. Almost all the popular magazines advertise such a service which is relatively inexpensive—five dollars. One such place is Congers Color Labs, Dept. C79, Congers, New York 10920. Be prepared to wait. We found that it took approximately three weeks for delivery.

Draw the square pattern on your photo blowup so you'll know where to place the photograph on the cube. Fold on the lines. In this way you can make the necessary cuts. (See diagram.)

Lay the cut photo on a large flat surface in order to prepare it for dry mounting to the cube. To do this you will coat the entire back of the enlarged photograph with rubber cement. Next, coat all exposed sides of the cube with rubber cement. Let each of these dry, which takes just minutes. In order to mount the photo so each is straight on the cube and wrinkle-free, a slip sheet is necessary. This is a piece of tracing paper that is placed between the cube and the photo while you are working. Line up the edge of the photo with the edge of the top area of the cube with a piece of tracing paper separating the rest of the photo and the cube surface. Slide the slip sheet down and out from under the photo as you smooth the photo in place. Work with one narrow area at a time to avoid problems. The photograph will bond permanently. However, if you make a

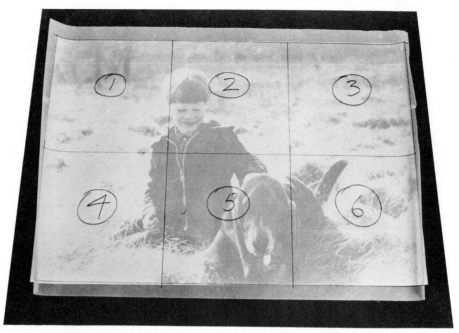

Sections 1 and 3 will be cut away.

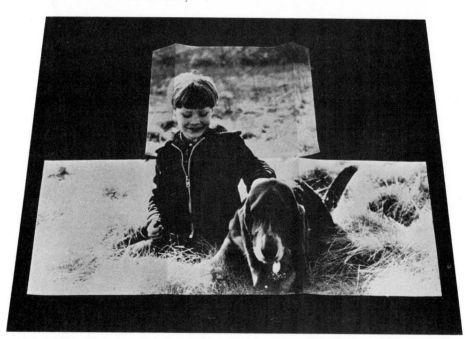

Top (square #2) will be mounted first.

mistake, you can remove the photo with rubber cement solvent and start over. If this happens, reapply the rubber cement to both surfaces as before and follow instructions from the beginning. Once mounted, smooth all areas to be sure the photograph is mounted perfectly to the cube. If trimming is necessary at the edges, this can be done with a sharp razor blade.

This table is meant as a decorative piece and is not necessarily a place to have lunch on. If you put a wet glass on top of the photograph you can ruin it. The paper is not soil-proof. To protect the

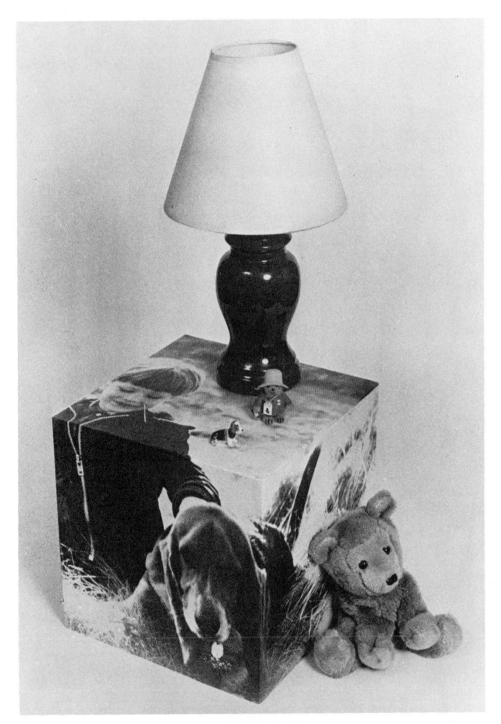

surface, however, you can have a glass top cut to fit. Hardware stores can usually provide you with this service. To have an accurately cut top, make a tracing of the area to bring with you. In this way if the cube is not a perfect measurement, the glass cutter can accommodate for this. Another way to protect the papered surface is with a coating of indoor wood varnish. Either a high gloss or matte finish can be used. Apply the varnish with a sponge applicator or inexpensive flat paintbrush. Two or three coats will be sufficient. Each must dry thoroughly before applying the next.

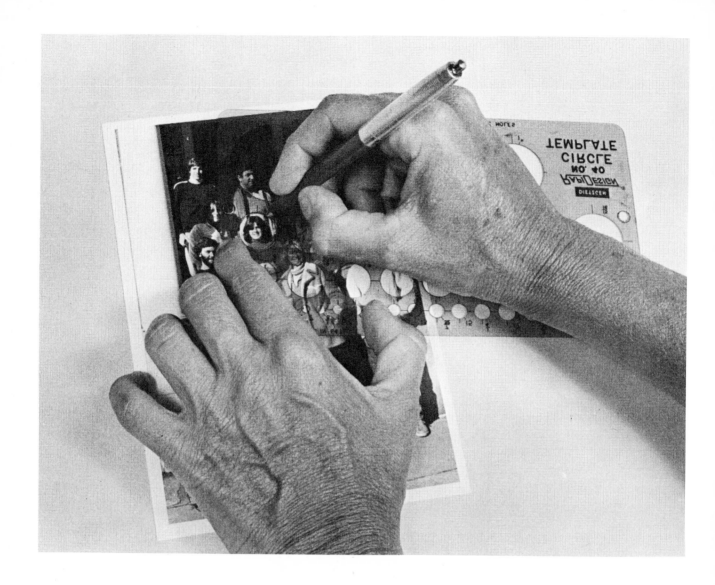

A Family Tree

A family tree is a way of displaying photos of your family in relation to one another. Each "apple" on this tree is a family member. The design is flexible enough to add a member here and there. The illustration of a tree is provided here for you to trace, then transfer the design to a sheet of colored construction paper. For this project we used four colors. The background, tree trunk, treetop, and circles contrast in different colors.

The ideal way to cut all the circles is by using a circle template as shown. However, you can make your own circles by drawing the necessary size circle on stiff paper such as a file folder or shirt board. Cut out the circle and use the template to draw all the other circles on the photos to be cut out. Cut the circles with a sharp scissors. I find that cuticle scissors are easy to work with for small projects such as this.

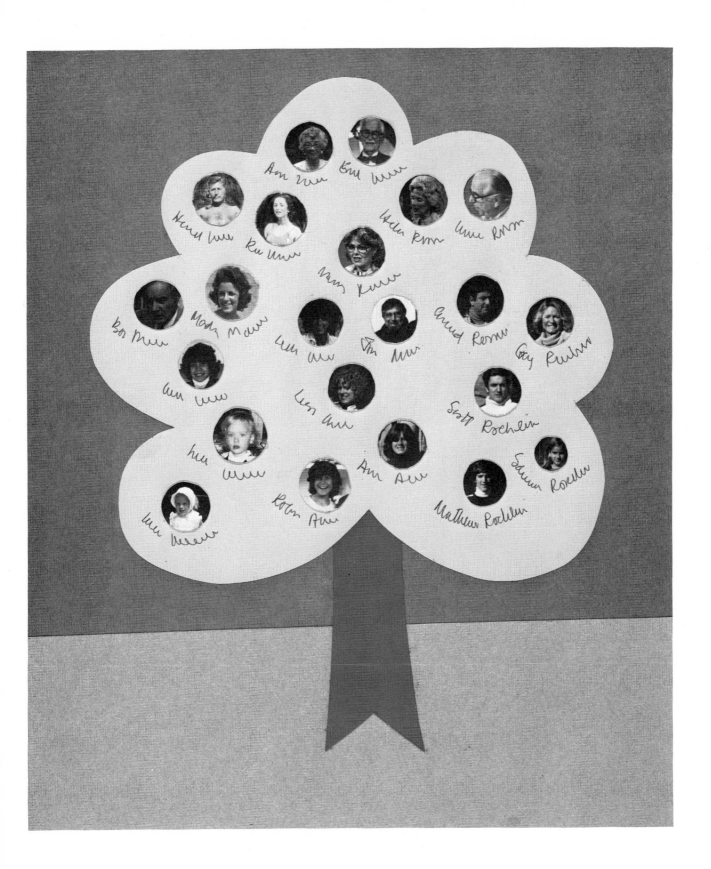

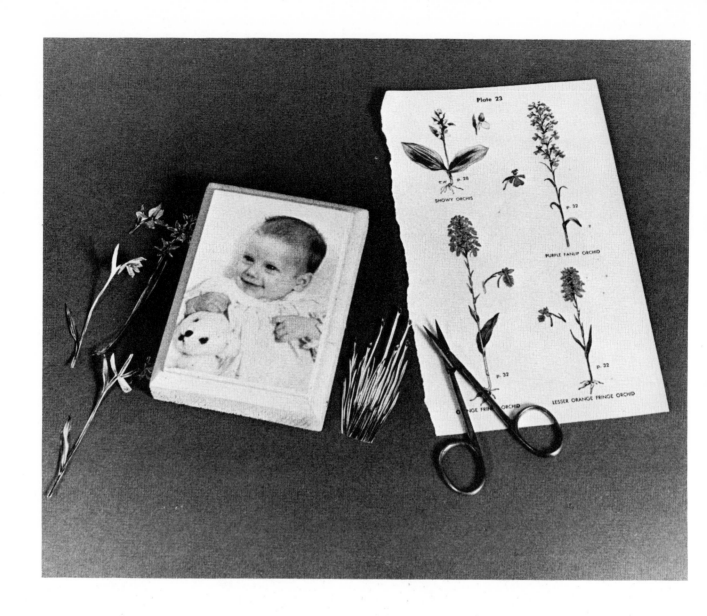

Baby Plaque

This newborn baby's picture is decoupaged on a plaque and hung from the top by a small brass ring. Once you have the picture, find a plaque that is the correct size. These are available at craft shops.

Paint the plaque with spray acrylic or latex paint. Mount the baby's picture using white glue. If you prefer, you can cut the figure of the baby out from the background. Select a gift-wrapping paper with a pattern you like that will go well with a baby's picture. Using

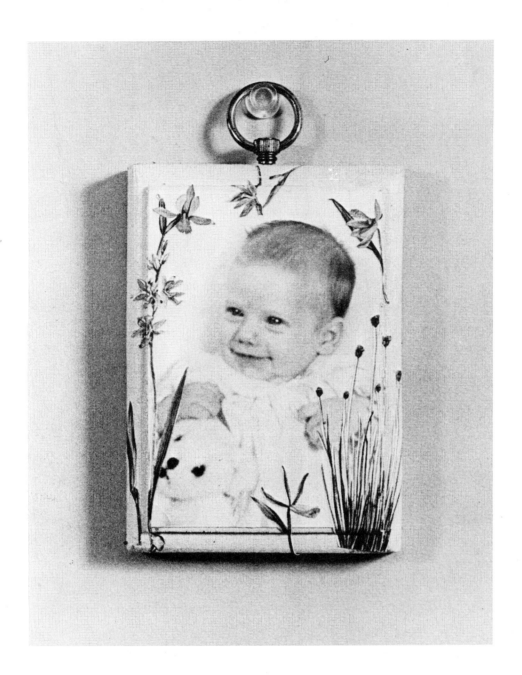

cuticle scissors, cut out the designs. Arrange them on the plaque in several ways before making the final selection.

Glue the cutouts around the plaque, overlapping some onto the photograph. Coat the entire thing with indoor wood varnish and let it dry overnight. Repeat this procedure several times until the photograph feels smooth when you run your hand across it.

A piece of felt can be mounted to the entire back of the plaque and a brass screw-ring inserted in the center of the top. Or, you can use self-adhesive tabs for hanging.

Make Your Own Special Mats

Nothing enhances a photograph more than the way it is framed. But before your picture is framed it can be matted to create any look you want, depending on where it will be hung or what the picture seems to indicate. You might want it to look old fashioned, contemporary, or traditional. The mat calls attention to the picture in an appealing way.

There are many considerations to take into account before making your mat. The first is color. When choosing the color it is best to hold it up to the photograph to see whether it draws attention to or detracts from the picture. One photograph might look best surrounded by bold red, while another needs a subtle earth-tone

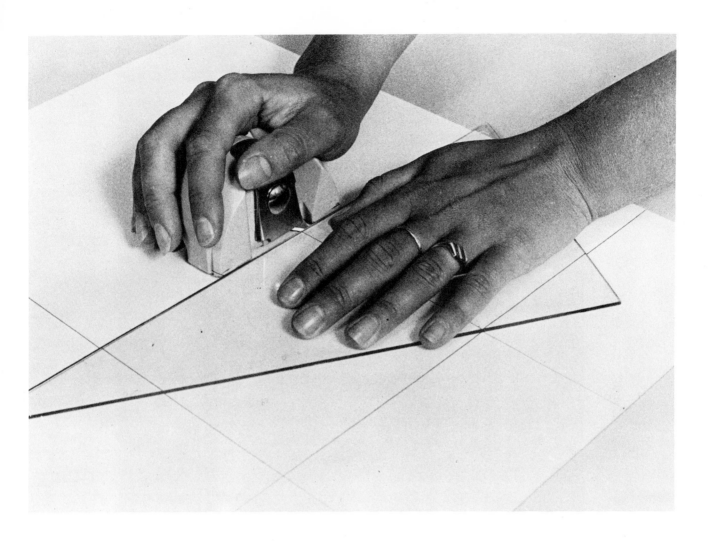

border. The next consideration is the size of the mat border. Sometimes a small picture is dramatized when placed in a wide, rather overwhelming mat. To determine the best size make a few tracings on paper to lay over the photo. This will give you an idea of how each will look when finished.

To make your own mats you will need a T square, a 45° triangle, a metal straightedge, a mat knife, and a mat cutter. All of the materials are available in art supply stores.

Consider the following in relation to your photograph. Where will the photo appear on the mat? A photograph does not have to be placed squarely in the center of the frame. Try it in one corner, for instance. Determine how large you want the overall mat to be. It's easiest to get standard-size frames, so keep this in mind when planning the mat size. A large mat offers some interesting possibilities for a small picture. Use more than one color. For instance, three

different shades of the same color will create a triple matting border. You can create borders of contrasting colors picking up shades from the room. Combine all the colors with unusual geometric shapes. One border might be cut square while another inside of this can be shaped. The shaped mat will offer a narrow border of one color while the surrounding mat color will dominate.

Most camera shops sell mats and carry a stock of gray, beige, black, and white. For more ususual colors you will probably have to go to a framer or art store.

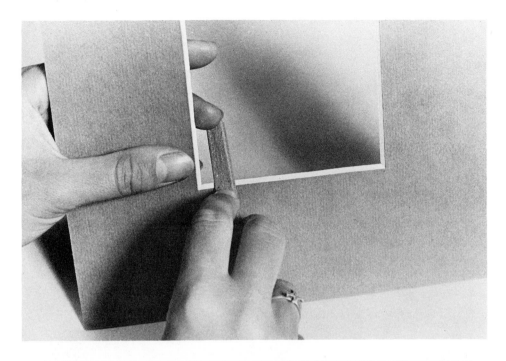

Decide what area of your photograph will be shown to determine the size of the hole to be cut out of the mat. Measure this area and when cutting, make the hole approximately a quarter inch smaller so that the photo can be taped to the back. Draw the hole dimensions on the back of the mat.

A mat or craft knife is used to make a straight-cut mat. Place the straightedge along the pencil line to be cut. To cut the board, draw the knife toward you along the straightedge. Do not let the blade lean to one side or the other. Cut with care from corner to corner.

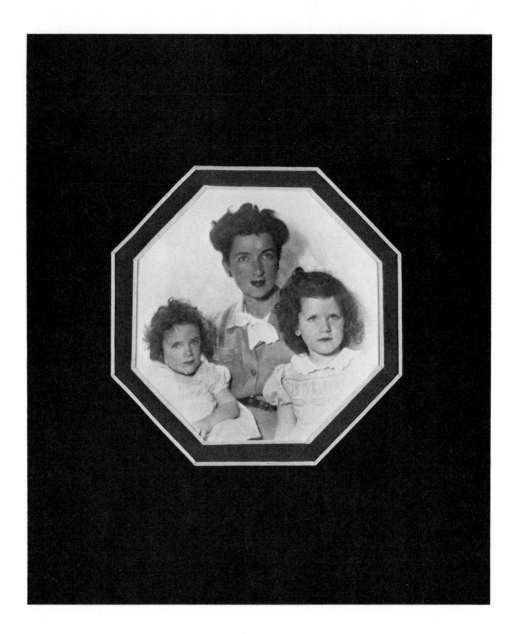

If the corners don't cut all the way through, carefully finish the cut until the piece to be removed is free.

Use the mat cutter for beveled cuts. There are various devices for cutting mats. Some are simple hand bevel-cutters like the one used in this demonstration. Others are more complex and are used by picture framers. To make a bevel cut, place the straightedge along the pencil line as a guide for the mat cutter. Push the mat cutter along the straightedge going away from you. Go 1/8 inch beyond the corner of the pencil lines. Practice making bevel cuts on scrap mat board until you get a feel for it.

If the corners of the mat are not cut all the way through, cut them with a very sharp blade. Rough sections along the beveled edge can

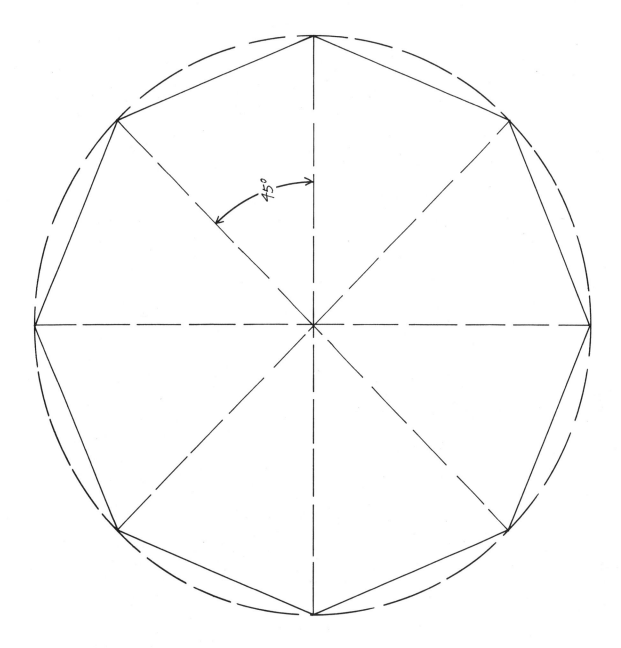

be sanded smooth with an emery board. Since the mat board is soft, sand carefully.

The double and triple mats shown are done by using the same method. Planning and careful measuring will insure perfect results. The mats can be held together with double-faced tape.

Once you know the technique for cutting a mat, you can make geometric shapes like stars, trapezoids, and triangles. A double-octagonal mat is made like a rectangular mat but requires more cuts and greater accuracy. An octagon is easy to construct with a 45-degree triangle and T square. (See diagram.) Be sure to select a photograph that is just right for the shape of the mat you create.

The discarded pieces from the octagonal mat were used as a frame also. The shapes are separated by blocks of balsa wood.

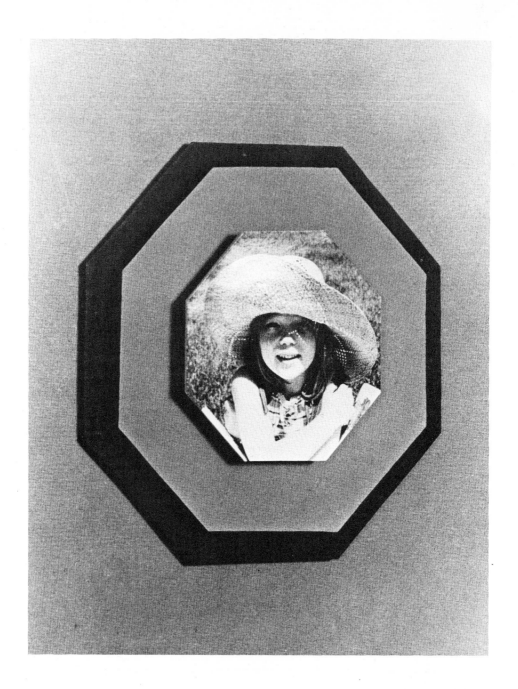

While this is the end of *Photocraft*, it should be just the beginning for you. Having discovered the potential for using snapshots in various creative ways, you will take pictures differently. Sometimes an idea for a personal gift will dictate the sort of snapshots that would best serve this purpose. Choose a project and a theme. Taking pictures will be more fun with this in mind.

Combine picture taking with picture projects for a new hobby. This expanded use of photos will create a new awareness for you. Use your imagination when buying ready-made products. A common novelty item can easily be turned into a unique gift by personalizing it with a special photograph.